WALTER
BENJAMIN
REIMAGINED

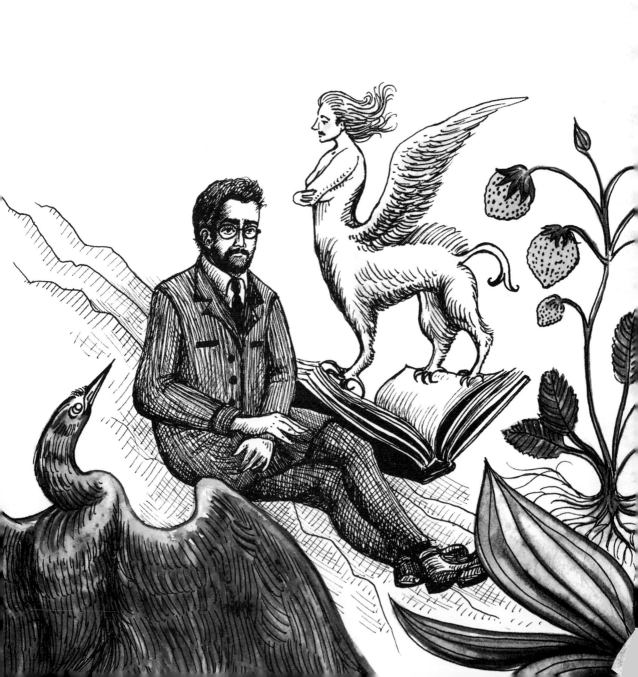

WALTER BENJAMIN REIMAGINED

A GRAPHIC TRANSLATION OF POETRY **PROSE** APHORISMS & DREAMS

FRANCES CANNON

FOREWORD BY **ESTHER LESLIE**
AFTERWORD BY **SCOTT BUKATMAN**

THE MIT PRESS CAMBRIDGE, MASSACHUSETTS LONDON, ENGLAND

This book was set in Berthold Akzidenz Grotesk by The MIT Press.
Printed and bound in the United States of America.

Library of Congress Cataloging-in-Publication Data

Names: Cannon, Frances, artist. | Leslie, Esther, 1964– writer
 of foreword. | Bukatman, Scott, 1957– writer of afterword. |
 Adaptation of (work): Benjamin, Walter, 1892–1940. Works.
 Selections. English.

Title: Walter Benjamin reimagined : a graphic translation of poetry,
 prose, aphorisms, and dreams / Frances Cannon ; foreword by
 Esther Leslie ; afterword by Scott Bukatman.

Description: Cambridge, MA : The MIT Press, 2019. | Includes
 bibliographical references and index.

Identifiers: LCCN 2018046687 | ISBN 9780262039963
 (hardcover : alk. paper)

Subjects: LCSH: Cannon, Frances—Themes, motives.

Classification: LCC NC139.C326 A78 2019 | DDC 741.6— dc23
 LC record available at https://lccn.loc.gov/2018046687

10 9 8 7 6 5 4 3 2 1

CONTENTS

MOVEMENTS

FOREWORD
BY ESTHER LESLIE

LINES AND LINES:
ON DRAWING, BENJAMIN, AND DRAWING BENJAMIN

WORD AND IMAGE

In February 1866, Ange Pechmeja, a poet and journalist who loved to sketch, wrote to Charles Baudelaire, expressing admiration for the "sensuous interfusion" in the poet's language. He writes: "I would say something more: I am convinced that, if the syllables that go to form verses of this kind were to be translated by the geometric forms and subtle colors which belong to them by analogy, they would possess the agreeable texture and beautiful tints of a Persian carpet or Indian shawl. My idea will strike you as ridiculous; but I have often felt like drawing and coloring your verse!"[1] Walter Benjamin cites this letter in his vast work of quotations and comments, the *Arcades Project*, which he worked on, yet never completed, in the final thirteen years of his life. Pechmeja's proposition—to draw and color the verse, as the words themselves are evocative of colors, shapes, and patterns—might equally be transposed onto Benjamin's own writing, which likewise exudes "sensuous interfusion." Benjamin's writing offers itself up in many ways to the translation of words into images. For one, Benjamin's essays are woven text, like carpets, full of different threads, ornaments crafted out of the raw material of experience, arabesques of understanding, replete with lines of thought that twist into graphic images, sensitive to sensation and tints in the world, worked and worked over to render the contents into an image, conveyed by words, but

1. Quoted in Walter Benjamin, *The Arcades Project*, trans. Howard Eiland and Kevin McLaughlin (Cambridge, MA: Harvard University Press, 1999), 284.

lingering in the mind as scene, as setting, as vignette—be those contents loneliness or conviviality, a family home, a carriage ride to the seaside, a look into a lover's eyes, books in a personal library, the announcement of an uncle's death, an imperial classroom, trees on the horizon, a mechanical chess player. Paul Klee's *Angelus Novus* (1920), a few lines of sketchy ink, oil pastel, washed in watercolor, is written about in a few lines by its owner, Walter Benjamin, and his lines are so intense, so brimming with something more concentrated than description, that they model the image, or remodel it, bringing it into being differently from Klee's Angel, which now becomes only one version. The new angel, the new angel renewed, is one who has a distinct political sensibility, an attitude toward the world; and the reader sees something through its eyes that is not present in the image—the piling rubble of past history—and, brought into being like this, it cannot be unseen again. If this is ekphrasis, it wills a new work of art into the world of the mind.

DRAWING THEORY

Benjamin's melding of image and words, of lines with lines, is a contribution to "the universe of intertwining," as he termed it in an essay on Proust, a tangled universe that Benjamin inhabited and rendered for his readers.[2] This is a world in a state of similarity, where there are correspondences, analogies, slippages. The world is enlivened. An owl's eyes echo the knots on the bark of a tree. It is a world in which a child can be a curtain or a column, a tree, a peach, or a table leg. Animal, vegetable, mineral: not separate kingdoms but overlappings. Children know this best, as Benjamin indicates in his phrase "the whole distorted world of childhood." Those alterations make the world pliant. Language too blunders and shifts, its twists presenting to him the cloud-like possibilities of poetic other-thinking. The blank spaces of the world, those deadened zones in which adult experience is attenuated, fill up with thoughts, words, images, the debris of a curious

2. Walter Benjamin, "On the Image of Proust," in *Selected Writings*, ed. Marcus Bullock and Michael W. Jennings, vol. 2 (Cambridge, MA: Harvard University Press, 1999), 244.

life. Snowflakes amass on a window ledge in the boy's bedroom like words smashing together into racy sentences from an adventure novel.[3] The blank space of the page is filled with lines, words, images, rubble, and building blocks of thought and other-thinking.

As he prepared the manuscripts for his essays, Benjamin would jot down groups of words, wind-roses of concepts, doodles, and scribbles that produced relationships between ideas and turned the linearity of the sentence into constellations of thought-stars dancing across the pages. A handwritten manuscript on Baudelaire's literary reception sketches out eight thoughts in clumps angled toward or against each other across the page, depending on their relation. Writing on Proust, he puts boxes around clusters of themes and brings them into connection with each other with linking lines. Thought is made graphic and relational. Thought is in a force field. And of Mallarmé, he noted with some delight that the word, or more specifically the line, was becoming image, prompted by the new word-picture language of advertising:

> One day he invited Valéry to be the first to see the manuscript of "Coup de dés." "Take a look at it and tell me whether I have gone mad!" (This book is known from the posthumous edition of 1914. A quarto volume of a few pages. Words are distributed across the pages in changing typefaces, separated by quite considerable and irregular distances.) Mallarmé, whose rigorous immersion in the midst of the crystalline construction of his manifestly traditional writing beheld the true image of the future, has here processed the graphic tension of the advertisement, for the first time (as a pure poet), in the actual image that the writing forms.[4]

While intoxicated on mescaline in 1934, Benjamin doodled an embryonic shape of twisty lines that is composed of

3. Walter Benjamin, *Berlin Childhood around 1900*, trans. Howard Eiland (1932/1938; Cambridge, MA: Harvard University Press, 2006), 59.

4. Walter Benjamin, "Paul Valéry in der École Normale," in *Gesammelte Schriften*, ed. Rolf Tiedemann and Hermann Schweppenhäuser, 7 vols. in 14 (Frankfurt am Main: Suhrkamp, 1972–1989), vol. IV, part 1, 480, cited in *Walter Benjamin's Archive* (London: Verso, 2007).

words from lullabies, and puns between the words for sleep and sheep—sleep, little child, sleep; sleep, my kiddikin, go off to sleep, sheep, little sheep. It is word and image at once.

Benjamin's writing comes at this intermeshing of image and word as a writing that absorbs image, exudes image, wanders between lines of text and lines that comprise the formational imagination which deposits images in the mind. Words flow like rivers, their lines gushing through landscapes of meaning and unmeaning. What unites word and image, language and drawing? Each, once set in motion, has a line. As his possession of *Angelus Novus* suggests, Benjamin loved the work of Paul Klee—a play of lines, of letters, of words, of wayward scratches. Benjamin understood Klee's work to teach that the image and writing have touching points. Through Klee's line, what Benjamin calls his "linear structure," the image joins to the sign, and so to writing. This merger of writing and drawing engages and disengages a contemporary historical experience of the interwar years when Klee and Benjamin lived and produced. In that universe, image and word interweave and recalibrate in the posters and mobilize in the neon coils of logos and advertisements.

For Benjamin, words in a dream become picture puzzles, wordless, decipherable, or enigmatic. Images turn into words— and in so doing, they might call up the possibility of utopia, as does the advertisement in one of Benjamin's examples. Once, when riding through Berlin as a passenger on a train, Benjamin saw a remarkable advertisement. It was a synthesis of poetry and painting, and it stamped itself upon his mind with such force that it bashed through the floor of his unconsciousness and lay dormant there for years. He could recall only the advertised commodity, or its name, but not the image—though he knew there was something extraordinary about it. One day, traveling through the city again, he stumbled across an out-of-the-way bar in a working-class district. Among its forest of enamel signs was a simplified version of the advertisement for the same brand of salt. Its name, its reference to the earlier image, caused the first to suddenly return: salt spilling from a sack, loaded on a truck, in

the desert, heading toward a sign in the distance which reads "is the best." As it drips, the salt in the image spells out "Bullrich-Salt." Benjamin observes that this word-image captures capital's prompting of the fantasy of a predestined harmony between product, nature, and desire.

Paul Klee experimented with a walking line, which was also an element of his pedagogy, as explored in his *Pedagogical Sketchbook* from 1925, designed for his Bauhaus art school courses. A walking line has, for him, a freedom, as a dot or a mark extends itself over a page. A line, in being drawn, becomes complex, undertakes twirls, walks for walking's sake, is embellished with more lines, with complementary forms, an amplification all the way from dot to plane. Benjamin identified Klee's art as material that facilitated imaginative adventures, and, in this particular way, it offered up a mode of learning about the world and worldlings.

Through Klee's line painting—as in the world of children's picture books, which were another of Benjamin's fascinations—flat mirroring, the dull replication of reality, is abandoned by lines that fly free from marking out the edges of an exact reality, lines that might transform into words or turn words into image. In children's books, where word and image frequently play together, the world is apprehended not as an accurate display for pacified contemplation, but rather as an entity to be appropriated, imaginative in its outlines and colors, and to be re-created in the imaginative activity of children.

Of course, see a limit, exceed it, as Hegel said. Of course, see a line, take it for a walk, as Klee said. The line that has gone for a walk is a point that has been set into motion. The time that it takes to traverse the paper becomes spatially apprehended. The line is the result of movement, of the animation of the dot. The line walks. Walking, conversely, is a type of mark making, a tracing or stamping out on landscape—and is, perhaps then, by extension a type of writing, writing on ground. For Klee, in any case, the walking line in his pictures becomes ever more harnessed to writing, or to sign making. "At the dawn of civilization, when writing and drawing were the same thing," notes

Klee in *The Thinking Eye*, and it is back or forward to this dawn that Klee will get.[5] The flâneur is a walker too, tracing lines on the landscape, or the cityscape, more likely. Benjamin wrote of the flâneur, but he was himself one too, wandering through the cities of Paris or Berlin or Moscow, observing and seeking out experience. For the flâneur, the landscape is a book, or is read as a book. And the book will become more like a landscape, crammed with images, vistas, urban prey to capture, to make into poetry or image. Klee's line going on a walk captures the shifting, transforming and transformative dynamic power of the line that can be set in movement. But he is also a bulwark against it—bringing that line into the shape of letters, which form not narratives but fragments, poems, riddles, enigmas. Such forms enthralled Benjamin. And handwriting, a writing out of lines by hand, railed against the tyranny of print that was beginning to overtake the world in which they both lived and produced. Words, twirling, scattered, hand-drawn words gained a relationship to freedom—*parole in libertà,* as the futurists call it. Words as images, images as words, are elusive—flying by like shadows of the night; and here in the blank space of the page, in the dreamt-up cities that are yet to be built, there is room for more, for other free thoughts or walking and wandering lines.

One of the lines that courses through Benjamin's work is the line of technological development, especially the line that moves from drawing and painting to photography and film. Benjamin is fascinated by the gradations between them. This is no broken line, even though the move from drawing to photography is momentous in many regards. He reflects on the shift in the *Arcades Project*, pointing out the arrival of the "physionotrace, which, for its part, represents a mechanization of the process of cutting silhouettes." The shadow cast by the machine in candlelight automates the process of drawing. The image maker becomes a human machine tracing a line around a cast shadow.

5. Paul Klee, *Notebooks*, vol. 1, *The Thinking Eye* (London: Lund Humphries, 1978), 103.

Benjamin cites photographer Gisèle Freund's critique of the silhouette-cutting machine:

> The reproduction time with the physionotrace was one minute for normal silhouettes, three minutes for colored ones. It is characteristic that the beginnings of the technologizing of the portrait, as instanced in this apparatus, set back the art of the portrait qualitatively as much as photography later advanced it. "One can see, on examining the quite enormous body of work produced with the physionotrace, that the portraits all have the same expression: stiff, schematic, and featureless…. Although the apparatus reproduced the contours of the face with mathematical exactitude, this resemblance remained expressionless because it had not been realized by an artist." Gisèle Freund, *La Photographie au point de vue sociologique.*[6]

In response to this, Benjamin wonders how it is the case that "this primitive apparatus, in contrast to the camera" excludes "artistry." The schematic stiffness it produces suggests that the lines it traces do not flow, do not walk in freedom, and cannot produce—or reproduce—individuality and idiosyncrasy. But if artists got their hands on machines, as suggested by Louis Figuier in 1860 and cited by Benjamin, what might happen?

> The lens is an instrument like the pencil or the brush, and photography is a process like drawing or engraving; for what the artist creates is the emotion and not the process. Whoever possesses the necessary skills and happy inspiration will be able to obtain the same effects from any one of these means of reproduction.[7]

There is the unbroken line, the optimism that all means of reproducing the person, in the right hands, capture outlines that are particular, authentic, and truthful. This person whose outlines are caught, like the line itself, is on a journey: to have experience, to be alive, is to travel, according to the German language, which links *Fahren*, travel, to *Erfahren*, experience. Benjamin tracks the lines that come about by hand and mechanically,

6. Benjamin, *The Arcades Project*, 676.

7. Cited in ibid., 683–684.

and he seeks out what degree of freedom resides in them, how independently they exist from the world, which might then mean they become mere conveyors of fantasy, lines of escape. How tightly do they cleave to the world, remaking it in the image of those who dictate the line, as in the lines of disciplined human ranks in the Fascist rallies, who reflect back a pattern, but not one that is freely made? How much do these lines dance above the world, refracting it into imagination, revealing obscured outlines that are routes into an "optical unconscious," a machinic seeing that communicates to us behind the back of ideology? How much do these lines relay the distortion that is the world in all its bizarre outlines?

DRAWING WALTER BENJAMIN'S WORLD

Frances Cannon's drawings, fused with lines of Benjamin's scripts, wander freely and exuberantly across the pages. Her lines mingle with Benjamin's. Her play with his thoughts and with the images that resolve from his writing, and with the images of his writing that exist in the world—the photos, postcards, sketches in his hand, the scans of his micrographia or his sheaves of quotations copied out in the Bibliothèque Nationale onto specially acquired paper—scatter across the pages. Lines are snipped or lured out of Benjamin's writings. These are encircled by the lines of drawings, sometimes heavy lines as if to emphasize the indelibility of objects, scenes, and pictures as they come to take up residence in memory—not just Benjamin's memory but the memory of a number of people as they pass through a passage of time, his time, as well as the time of those who read subsequently and so prosthetically adopt those memories: a train set, a photograph of a seaside donkey, a toy boat, a peacock feather, a quill pen, a butterfly, such fragments as have been passed into and out of Benjamin's memory and were recorded in his writings on his childhood in Berlin. There is an attention here to silence, to what is lost to memory, which is to say not lost at all, but existent only in memory. And that memory attempts to be so capacious, it can recall even what might have happened but did not, the histories

that ran along parallel lines, the lovers that swerved and followed another path. Memory is a magic encyclopedia.

Cannon's drawings and their lines of writing scatter lines on the paper as if they were leaves in a spell book of a particularly anarchic type. At work across the pages is mutation—magical, animated, evolutionary, and revolutionary. Shapes beget shapes. Thoughts beget thoughts. Images beget images. And each of these begets the others. A bird's wings turn into the pages of a book, a wind-rose is a bicycle wheel. We reveal to ourselves our monstrousness, about which we may remain silent. Here, dispersed across the pages, lines—images *and* words—collate to form two of Benjamin's favorite things. One is rebuses, which insist on being solved by pulling a reader into action, into interpretation of the clues deposited in the image. The other is miniature forms, which shrink the world into studiable lessons. In the dream, perhaps, both these things coincide.

Benjamin observes that "history decays into images, not into stories."[8] It is image. It is a tableau. Something is stilled—the flow of time, the meaningless flutter of historical movement. It is image. This image becomes words in analysis. Also the notion of decay, as used in Benjamin's phrase, indicates that something breaks down, that history breaks down. In criticism it decays. These lines, historical lines, lines of drawings, run on and on, until they are broken, broken off. Stilled, ruined, fragmented, they open up to interpretation. The stilled image, the photographic fragment, the small doodle yields significance. Benjamin's own life has—in repeated visualizations, in art, novels, stories, films, paintings, comics, and cartoons—broken down into images that tell stories, lines of flight, lines that lead into an imaginative image world, life lines of a sort. This graphic book, with its lines and lines, extends the life of Benjamin and his work along new lines. Be spellbound and reconfigured in following its lines!

8. Ibid., 476.

PREFACE
BY **FRANCES CANNON**

A TRIBUTE TO WALTER BENJAMIN, THE COLLECTOR

Dear reader, I offer you a graphic literary response to the work of Walter Benjamin. Whether you are already a Benjamin convert, an amateur, an expert, or if you have never heard or read his name, I hope that you will find some morsel of Benjamin's original wry wit and genius in this unconventional translation of his writings. Benjamin is the true author of this book—my project has been to render his words in hybrid form: a visual echo of his work.

Benjamin took a unique approach to all of his literary and critical writing, one of constant flux in form and content, one of experimentation and fragmentation. His work rests just outside the margins of the twentieth-century European literary canon, and Benjamin the scholar stands apart from his contemporaries in the Frankfurt school of philosophers. Perhaps he belongs instead at the table of literary brooders—both authors and their characters: Hamlet, Baudelaire, Duras, Plath, Bernhard, and Sebald—all of whom establish themselves as outsiders, set apart from "normal" behavior and creativity. These melancholics isolate themselves from society to wallow in solitude and ennui. Victor Frankenstein, for example, holes himself away in a windowless attic for a year to research and then constructs a creature out of cadavers. Benjamin, alone in his mind palace, drove himself nearly to madness with his philosophical investigations of the dark arts of capitalism, the phantasmagorias of underground Parisian commerce, and the mechanization of art in the age of technology.

Many of these melancholics—both the artists and their creations—wander aimlessly, either in pursuit of, or to escape from, their own dark states of mind. Both Walter Benjamin and Baudelaire wrote about the flâneur who saunters through the streets of Paris, usually at night, observing prostitutes, performance artists, and other spectacles of the human condition. These cultural observers appear to be exploring the streets of their own minds, more than the cities which they trace with their slow steps. W. G. Sebald's narrator in *Rings of Saturn* drifts slowly, alone, down the dreary coast of Suffolk in search of— what, a landscape haunted by death? During a conversation with Joseph Cuomo, Sebald spoke about the asystematic approach that he took to his research and writing process: "If you look at a dog following the advice of his nose, he traverses a patch of land in a completely unplottable manner. And he invariably finds what he is looking for."[1] This wandering, then, is nonlinear, not goal-oriented. Walter Benjamin wrote about the collector as an archetype, a generalized character who is to be both admired and pitied for his efforts of curating objects and books—one who revels in the non-goal-oriented process of accumulation more than in the objects themselves. It is the chase, the search, the quest, the walk itself that defines the work. The narrator in Barthes's *A Lover's Discourse* admits that "it is love the subject loves, not the object … it is my desire I desire, and the loved being is no more than its tool."[2] The love object dissolves in the process of loving; the mourned object dissolves in the process of mourning. The writing process is just as important as the result.

Among this chorus of melancholic characters and writers, Walter Benjamin's work appeals to me for its form—in his prose, he drifts between rigorous essaying and whimsical lyricism. I am also drawn to Benjamin's diverse, interdisciplinary

1. W. G. Sebald in conversation with Joseph Cuomo, collected in *The Emergence of Memory: Conversations with W. G. Sebald*, ed. Lynne Sharon Schwartz (New York: Seven Stories Press, 2007), 94.

2. Roland Barthes, *A Lover's Discourse: Fragments*, trans. Richard Howard (New York: Hill and Wang, 1978), 31.

interests. He was a man of letters, a respected art critic and essayist, a translator, an obscure philosopher of the early twentieth century, a journalist of the dirty underbelly of urban centers, and above all else, a collector, fulfilling his own favorite literary archetype. He collected cities, jobs, books, snow globes, postcards, paper ephemera, vintage objects, modern objects, treasure, and junk. Benjamin's obsessive collections are beautiful in their chaos. His most celebrated archive of intellectual scraps is the Arcades project. In this unfinished magnum opus, he endeavored to catalogue his observations of the Parisian underground market—the labyrinthian arcades, which housed, above all, outdated objects representing the remnants of a lost era. These alleyways of glass and steel hosted prostitutes, black-market merchants, and an enchanted fairyland of "rolls of licorice … stamps, letterboxes, naked puppet bodies with bald heads … combs swim[ming] about frog-green … umbrella handles … bird seed … sets of teeth in gold and wax…."[3] The arcades appealed to Benjamin as a demimonde, containing just as much darkness as magic. Benjamin had not yet reached the age of fifty before his work on the Arcades project was arrested: while in exile in Catalonia in 1940, he overdosed on morphine tablets to avoid being forcefully repatriated to France by Nazi officials. The Arcades project remains his most extensive unfinished work, yet even in this permanently adolescent state, it begs for conversation and response. The work reads to me like a secret diary of an anthropologist in the underworld—full of wit and mystery. Within this realm lurks Benjamin's writings on phantasmagoria. In the nineteenth and early twentieth centuries, this term described a method of optical illusions cast by magic lantern, shadow puppetry, and a theater of specters for entertainment. Benjamin applied the phrase more broadly to the visual culture of the arcades, the spectacle of the market, and to the commodification of artwork. In my own work, I use

3. Walter Benjamin, *The Arcades Project*, trans. Howard Eiland and Kevin McLaughlin (Cambridge, MA: Harvard University Press, 1999), 872.

illustration to communicate magic, myth, and story, much like the illusionary theater of Benjamin's era.

I am a prose writer and artist of hybrid mediums, namely of graphic literature, and I often find my own artistic practice reflected in Benjamin's body of work. He sampled and experimented constantly with genre and style, and he moved fluidly between journalism, poetry, criticism, and fiction. I particularly love his lists, marginalia, and open-ended meditations. His archival processes align with my own; I have long been inclined toward a type of autoethnography, as Benjamin seems to have been aiming for with his careful record of thoughts, dreams, cities inhabited, and philosophical musings. Similarly, I maintain a detailed record of my life in various forms: blueprints for imaginary homes, a daily journal dating back to age eight with illustrations and text entries, and lists of everything from early memories to peculiar names on gravestones. I am also drawn to this style of hybrid note-taking as a reader of contemporary graphic novels and comics. I resonate with texts that reveal the author's archival research process, particularly autobiographical comics such as Alison Bechdel's *Fun Home* and Marjane Satrapi's *Persepolis*, which both include visual representations of ephemera from the artists' pasts; Bechdel's graphic memoir includes illustrations of her old journal entries, photographs, to-do lists, reading lists, and letters, and Satrapi's graphic memoir includes sketches of her dreams, newspaper clippings, and even news events on television that she witnessed as a child. In this book, I aim to build a bridge between my reflexive process and Benjamin's, and the most appropriate form for this bridge to take is a visual journal of fragments which I have collected from his oeuvre: a graphic archive of his poetic clutter, an illustrated record of my reading of his work, a sketchbook I kept during an ambling walk through the labyrinthine museum which he built to house his thoughts.

Benjamin's alternate temporality calls for a nonlinear and unexpected response to his work, work which is intricately embroidered with anecdote and image. This has been my approach—to wander through his works, collecting, taking my own notes in

response to his prose, and then returning to illuminate frag-
ments of his writing. This process, in a way, is my nod to Ben-
jamin's collection of cultural ephemera, but with added critical
and poetic marginalia, as well as graphic illumination. I strive to
acknowledge the past and the present simultaneously, as Ben-
jamin suggests is necessary to emphasize the "now-time" over
"empty time." Perhaps by sifting through Benjamin's work and
applying my artistic eye to his theories and writings, I can render
an image of the "glamour" of his leaping tiger. I strive to breathe
imagistic graphic life into Benjamin's essays, which already burst
forth with dreamscapes, spirits, latent images, and works of art.
Through my graphic translations, I want to represent to the con-
temporary reader a diverse portrait of Benjamin.

My pen wanders a nonlinear path through his catalogue of
miscellany. I stroll through his text, embodying his archetype
of the flâneur—observer, detective, journalist, and participant.
I have physically retraced Benjamin's steps on my own visits
to the subterranean markets of Paris, where I too have fallen
under the spell of nostalgic clutter. This book is my visual phys-
iognomy—an illustrated map—of Benjamin's writing; a creative
topography of his collection, in text and image.

My project has been to illuminate excerpts from Benjamin's
essays, his dream journals, the Arcades project, and his short
fiction—both his finished and unfinished writings. By weaving
my own creative rendering in with his prose, I see this process
as an unusual form of graphic translation. I'm decoding his prose
into my own personal creative language, which involves further
fragmentation and visual elaboration. I sorted Benjamin's exten-
sive body of work into six thematic genres, which I represent
with the following title categories: "Artifacts of Youth," covering
his nostalgic musings on his childhood; "Fragments of a Critical
Eye," on his early writings and cultural criticism; "Unpacking My
Library," on curating one's own book collection, "Athenaeum of
the Imagination," on his meditations on psychology and philos-
ophy; "A Stroll through the Arcades," on his unfinished magnum
opus; and finally, "A Collection of Dreams and Stories," on his
more fantastical writings and experiments in fiction. My primary

artistic method is akin to a creative hoarding—assembling quotes, sketches, and images to then sort, curate, and reconstruct. Though my chaos is nowhere near as elegant as Benjamin's, the following drawings and poetic fragments are my attempt to echo his notes; an artist's phantasmagorical tribute to his wandering eye. My drawings and curation of fragmented texts reflect the spirit I see in his collection.

Throughout the process of engaging with Benjamin's work in image, I have held in mind Hélène Cixous's essay "Without End, No, State of Drawingness, No, Rather: The Executioner's Taking Off," from her book of theory and art criticism, *Stigmata*. This essay has been important for me to keep in mind while I attempt to translate Benjamin's work into the visual realm. Even the title communicates Cixous's hesitation, revision, and creative power. So, the "No, Rather" in the title is more than appropriate: the essay is a work in progress, a stream-of-consciousness display of the mind on the page. This essay embodies the linguistic origins of the word "essay," taken from the French *essayer*, or "to try," inasmuch as Cixous tries out multiple arguments and philosophical concepts as she writes.

She writes beautifully about the line shared by both word and image—the line that functions both in word and image, the drawn line, the tentative line of a handwritten letter, the doodle, the sketch, the chicken scratch in the margins of a book.

Cixous begins in a confessional, personal tone, exposing the intimacies of her artistic doubt, but she soon expands beyond herself into an intertextual, intercultural exchange of ideas. She starts by writing about her own work, "I just wrote this sentence, but before this sentence, I wrote a hundred others, which I've suppressed, because the moment for cutting short had arrived";[4] but soon she moves into an admiration of Kafka and Dostoevsky, and soon after this, leaps into an abstracted discussion of "Good" and "Evil" in artmaking. Already we get a sense of

4. Hélène Cixous, "Without End, No, State of Drawingness, No, Rather: The Executioner's Taking Off," in *Stigmata: Escaping Texts*, trans. Eric Prenowitz (London: Routledge, 2005), 16.

her argument without a single identifiable thesis. She rambles, ambles, wanders from thought to thought, and yet, that is the thesis—her very wandering. She is trying to prove to us through her syntactical style—her aimlessness—that the essence of art-making and writing is the expedition itself. Artists should remove our grip on an end goal and instead focus on the process.

Cixous emphasizes the importance of trial and error, and that so-called mistakes—such as the errors that might occur during translation—are essential to this process. Error signals progress itself. Her appreciation of the natural creative mutation which occurs during translation reminded me throughout my work on this project that I am not merely illustrating Benjamin's sentences; rather, I collect ideas within his prose and release them into a new form. I am translating his concepts into a parallel language—one of image, texture, visualized dreamscape, and figuration. I read between his lines and weave lines of my own using his textual template.

I have kept another literary compass on my desk during this process: a favorite text from my childhood, *The Dot and the Line*, written and illustrated by Norton Juster, who also wrote *The Phantom Tollbooth*. In this concise, graphic narrative, a "romance in lower mathematics" is told simply through line-work. The line is a character, who performs diverse tricks and twists to communicate emotion and philosophy. Juster's line as character allows me to approach Benjamin's work with a little humor, for the daunting task of translating the work of a literary genius requires a hint of levity.

On that note, I encourage you, reader, to wander through this work. Linger, leap ahead, collect fragments along the way, retrace your steps. Take your idle time.

ACKNOWLEDGMENTS

I must express my immense gratitude to those minds, eyes, and hands who helped me to create this book:

To Helen and Larry Cannon, Anna Ready-Campbell, and Janet Bennion—beloved and conscientious mentors, editors, and readers of my work.

To Estefania Puerta, Meghan Reynolds, and other colleagues in a strangely fruitful art critique group in Vermont, for your ideas and suggestions.

To Jeff Porter, who planted seeds of inspiration for this project by curating conversations about Benjamin, Sebald, Barthes, and Duras in a seminar on melancholy books at the Nonfiction Writing Program at the University of Iowa.

To Harry Stecopoulos, who expressed enthusiasm about this project in its earliest stages, and who published my graphic essay about Walter Benjamin's "The Collector" in the *Iowa Review*.

To Matthew Brown, who helped me redirect my amorphous research toward more specific essays by Benjamin.

To Victoria Hindley, for seeing potential in an adolescent version of this book, and for her patience and encouragement throughout the writing and editing process.

To Esther Leslie and Scott Bukatman, for their brilliant collaborations and contributions.

MOVEMENTS

I.
ARTIFACTS OF YOUTH

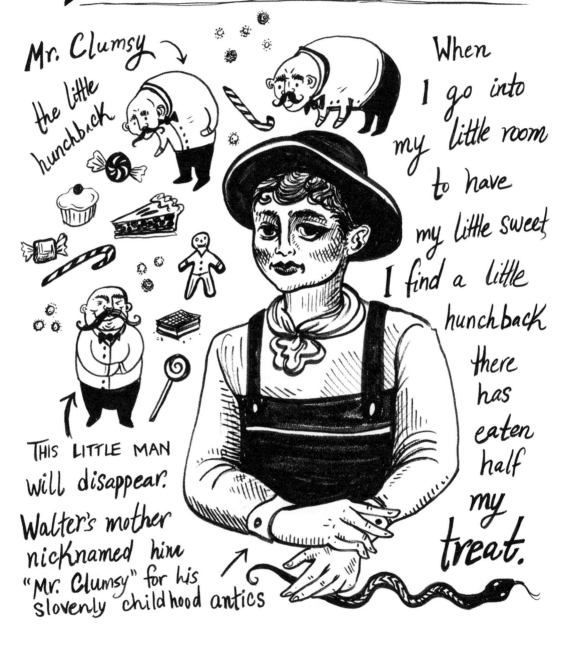

Walter Benjamin's
BERLIN CHILDHOOD around 1900

Mr. Clumsy
the little hunchback

When
I go into
my little room
to have
my little sweet
I find a little
hunchback
there
has
eaten
half
my
treat.

THIS LITTLE MAN will disappear.
Walter's mother nicknamed him
"Mr. Clumsy" for his
slovenly childhood antics

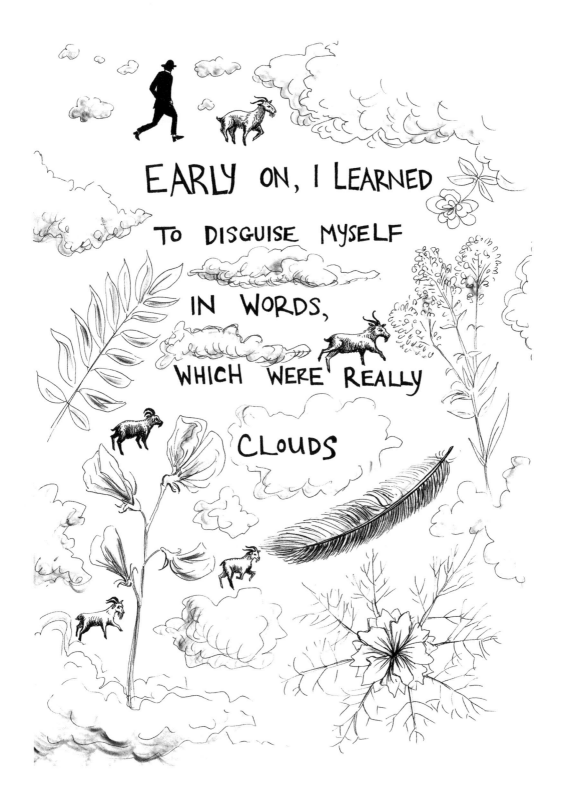

EARLY ON, I LEARNED
TO DISGUISE MYSELF
IN WORDS,
WHICH WERE REALLY
CLOUDS

CURRICULUM VITAE

I, Walter Benjamin, son of Emil Benjamin and Pauline
born July 15, 1892...
(née Schoenflies);
belong to the Jewish confession.
In 1901... I entered the fifth
grade at the Kaiser Friedrich
School... I had to withdraw
to recover my health... I entered
eighth grade at Dr. Lietz's
country boarding school, Haubinda...

MY PARTIALITY for LITERATURE, PHILOSOPHY...

My philosophical and literary interests have undergone
a natural synthesis in the formation of specifically
aesthetic interests... theory of drama... Shakespeare,
Hebbel, Ibsen, Goethe, Hölderlin... Whether it will be philosophy
or literature that takes precedence is something I cannot decide.

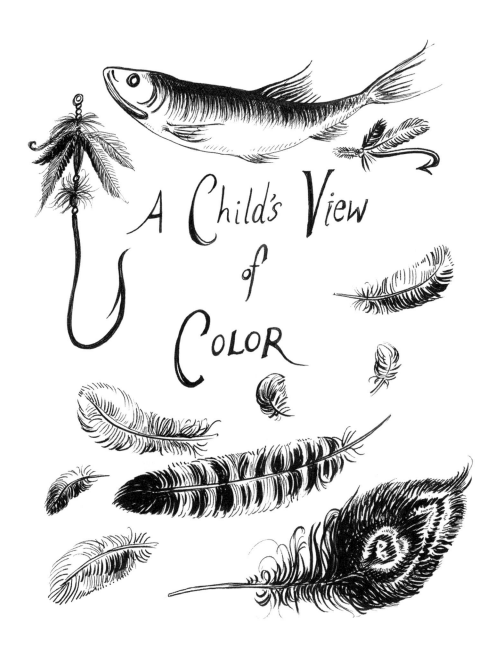

A Child's View of Color

Children enjoy the alteration of COLOR in a variable transition of nuances ~

SOAP BUBBLES,

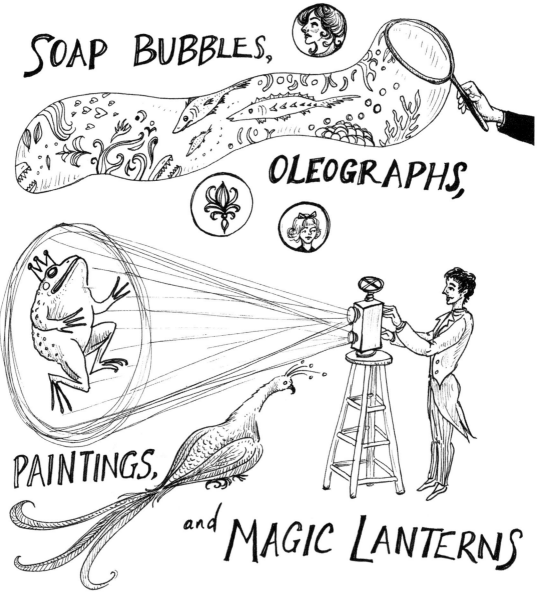

OLEOGRAPHS,

PAINTINGS,

and MAGIC LANTERNS

The WORLD is full of COLOR
in a state of identity,
innocence, harmony...

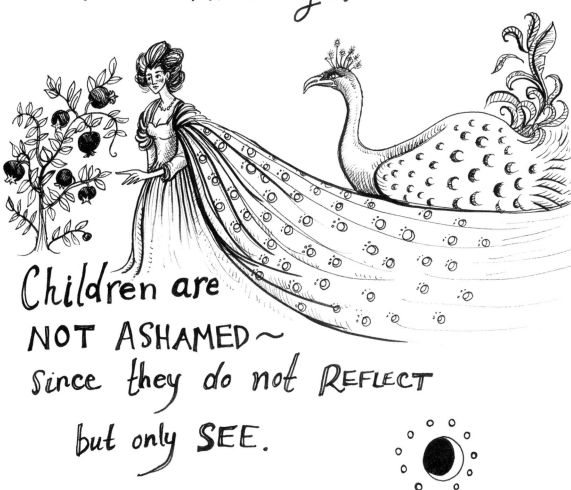

Children are
NOT ASHAMED~
Since they do not REFLECT
but only SEE.

Color is something SPIRITUAL, something whose clarity is spiritual or whose mixture yields nuance, not a blur. The RAINBOW is a PURE

CHILDLIKE

IMAGE

The resplendent, self-sufficient world of COLORS is the exclusive preserve of children's books...

artists and children swiftly came to an understanding over the heads of pedagogues

The TRUE AGING of PARENTS

is the DEATH of the child.

A LIST of THOUGHTS ON

RUSSIAN TOYS

- MODERN BALLET
- DEBUSSY : TOY BOX
- PRODUCTION PROCESS
- CRITERION of SIMPLICITY AGAINST MODERN TOYS
- STREET TRADING
- INTERNAL RUSSIAN & EXPORT
- CONDITIONS IN THE MUSEUM
- MASTERY IN FASHIONING WOOD TOYS, PAPER, PERFUME
- LOTS of SHOPS

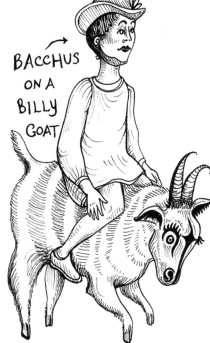

BACCHUS ON A BILLY GOAT

MUSIC IN THE CASKET

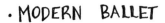

GERMAN TOY INDUSTRY

- TINY DOLL & ANIMAL KINGDOMS
- MATCHBOX FARM-HOUSE ROOMS
- NOAH'S ARKS
- SHEEP PENS

Task of CHILDHOOD: to bring the new world into symbolic space. The child, in fact, can do what grownups CANNOT: recognize the NEW once again. Every childhood discovers these new images in order to incorporate them into the image stock of humanity. Children provide the happy occasion for the awakening of the DREAM COLLECTIVE.

WHAT IS *truly revolutionary*
is the SECRET SIGNAL
of what is to come
that speaks from
the GESTURE
of the
CHILD.

II.

FRAGMENTS OF A
CRITICAL EYE

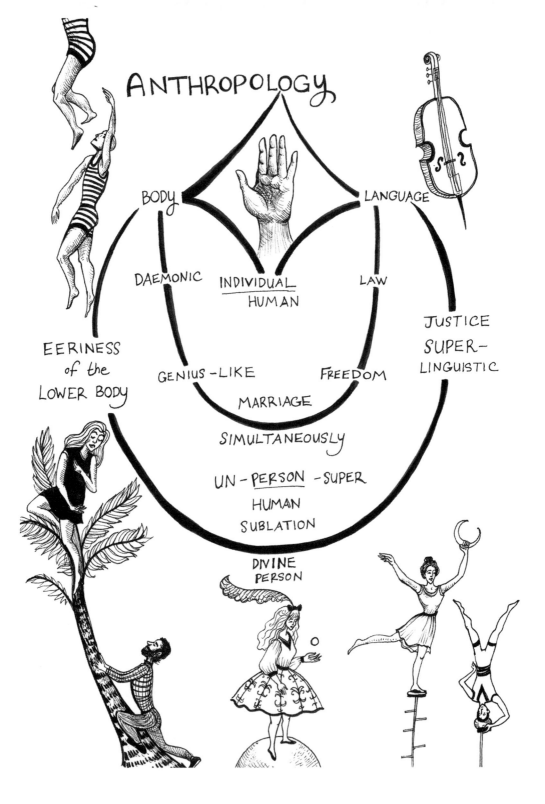

ANTHROPOLOGY

BODY — LANGUAGE

DAEMONIC — INDIVIDUAL HUMAN — LAW

EERINESS of the LOWER BODY

GENIUS-LIKE — FREEDOM

JUSTICE SUPER-LINGUISTIC

MARRIAGE

SIMULTANEOUSLY

UN-PERSON-SUPER HUMAN SUBLATION

DIVINE PERSON

The University is simply NOT the PLACE to STUDY.

A work of ART in and of itself, without reference to theory or morality can be understood in CONTEMPLATION alone, and that the person contemplating it can do it JUSTICE

The METAPHYSICS of YOUTH

Each day, like sleepers, we use
UNMEASURED
ENERGIES.

What we DO
and THINK
is filled with
the being of
our fathers
and ancestors.
An UNCOMPREHENDED
Symbolism unceremoniously

ENSLAVES US.

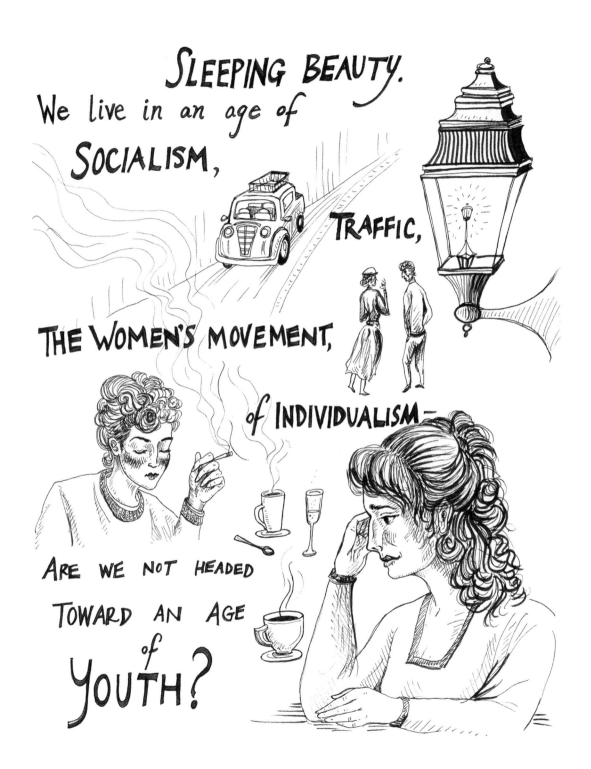

SLEEPING BEAUTY.

We live in an age of SOCIALISM, TRAFFIC, THE WOMEN'S MOVEMENT, of INDIVIDUALISM— ARE WE NOT HEADED TOWARD AN AGE of YOUTH?

Youth is the Sleeping beauty who Slumbers and has NO INKLING of the prince who approaches to set her free.

For how can a young person, especially one from the BIG CITY, confront the deepest problems, the social misery, without at least sometimes falling PREY to PESSIMISM?

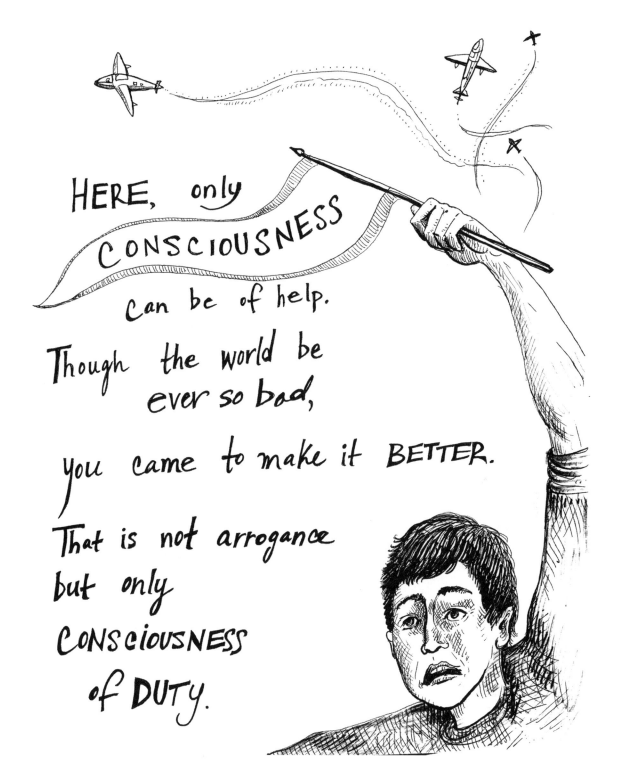

HERE, only CONSCIOUSNESS can be of help.

Though the world be ever so bad,

you came to make it BETTER.

That is not arrogance but only CONSCIOUSNESS of DUTY.

A CHRONICLER who recites events without distinguishing between MAJOR and MINOR ones acts in accordance with the following truth: NOTHING THAT HAS EVER HAPPENED SHOULD BE REGARDED AS LOST FOR HISTORY.

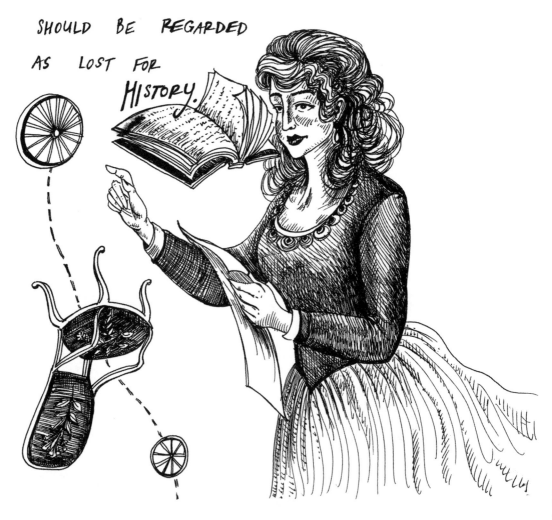

To articulate the past historically means to seize hold of a memory as it flashes up at a moment of DANGER.

The same threat hangs over both the content of tradition and its receivers: that of becoming a TOOL of the RULING CLASSES.

In every era the attempt must be made anew to wrest tradition away from a conformism that is about to OVERPOWER IT.

THESES ON THE PHILOSOPHY of HISTORY—
Whoever has emerged
VICTORIOUS participates
to this day in the
TRIUMPHAL PROCESSION
in which the RULERS
STEP OVER those

who are

lying prostrate.

According to
traditional practice,
the spoils are
carried along
in the procession.
They are called
CULTURAL
TREASURES,
& a historical materialist views them with
cautious detachment, for they have an origin
which he cannot contemplate without HORROR.

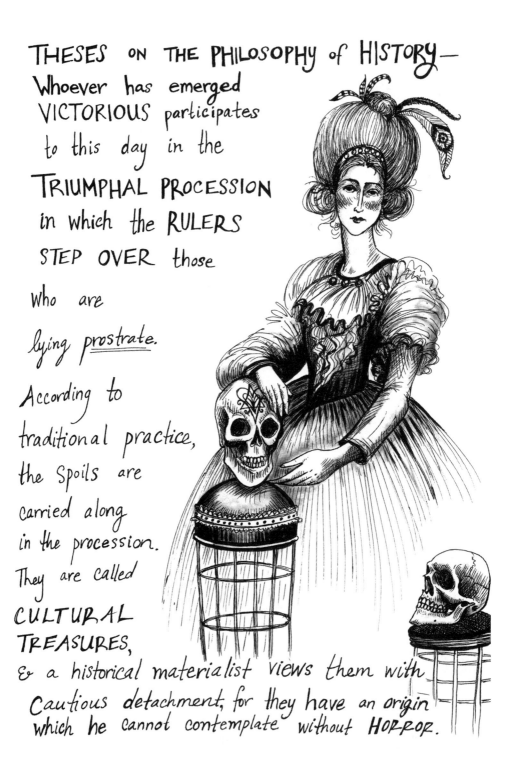

There is no document of CULTURE which is not at the same time a document of BARBARISM

Whatever form the present may take,
our task is to seize it by the horns
so that we can interrogate
the past. It is the BULL whose
BLOOD must fill the pit if the spirits
of the departed are to appear
at its edge.

The speaker is always possessed by the PRESENT.

SHE GUARDS THE TREASURE OF DAILY LIFE, BUT ALSO OF THE NIGHT, THE HIGHEST GOOD.

DIALOGUE on the Religiosity of the PRESENT:

"L'art pour l'art!"

ART is not the SERVANT of the STATE,
nor the HANDMAID of the CHURCH...

one does not Know where one
will end up with it—with art.
"l'art pour NOUS!"

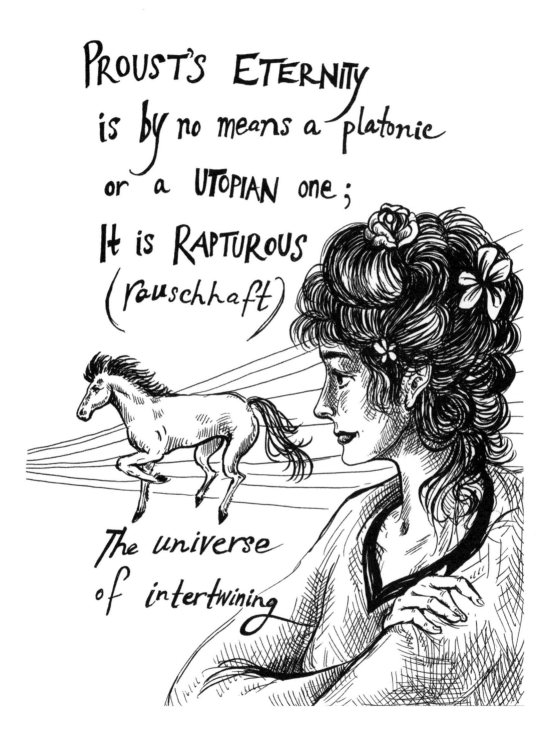

PROUST'S ETERNITY
is by no means a platonic
or a UTOPIAN one;
It is RAPTUROUS
(rauschhaft)

The universe
of intertwining

WORK ON GOOD PROSE HAS THREE STEPS:

A MUSICAL PHASE WHEN IT IS COMPOSED,

AN ARCHITECTONIC ONE WHEN IT IS BUILT,

& A TEXTILE ONE WHEN IT IS WOVEN.

RAGPICKER & POET:

BOTH ARE CONCERNED

WITH REFUSE.

METHOD of this PROJECT:

Literary Montage.

On the poem 'Of Poor B.B.' by Bertolt Brecht—
the poet comes to speak of his own poor soul,
forlorn like no other. It stands in the light,
and, what is more, on a SUNDAY AFTERNOON
by a DOG-STONE. <u>Of Poor B.B.</u>,

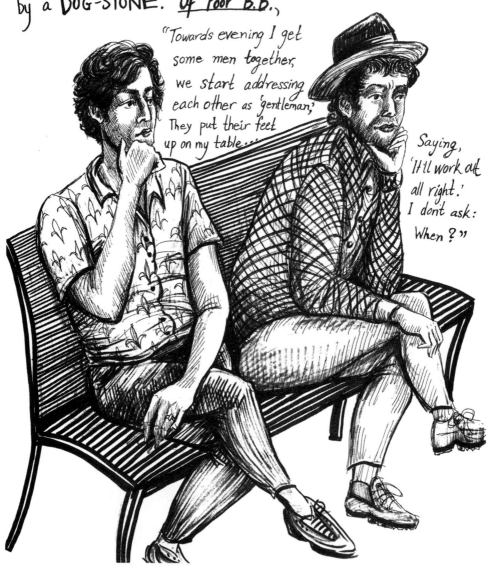

"Towards evening I get
some men together,
we start addressing
each other as 'gentleman.'
They put their feet
up on my table..."

Saying,
'It'll work out
all right.'
I don't ask:
When?"

CHAMBERMAIDS' ROMANCES of the PAST CENTURY

~ Das illustrierte Blatt, April 1929~

A start should be made with **CHEAP FICTION** and *Colportage*

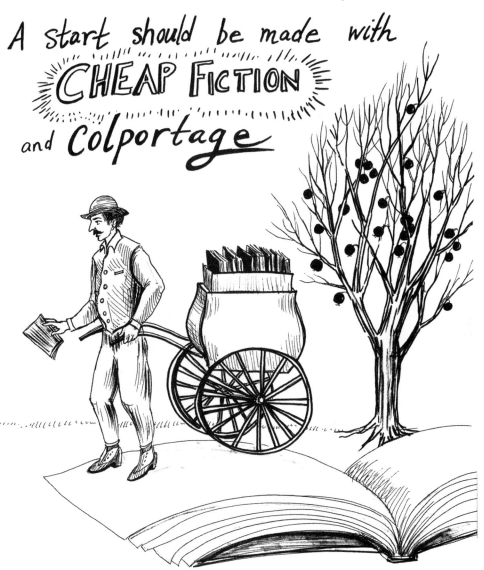

If indeed literary history is ever going to explore the geological structure of the book, rather than confining itself to a view of the PEAKS.

It is amusing to imagine the complete literary
traveling salesman of the past,

THE COLPORTEUR,

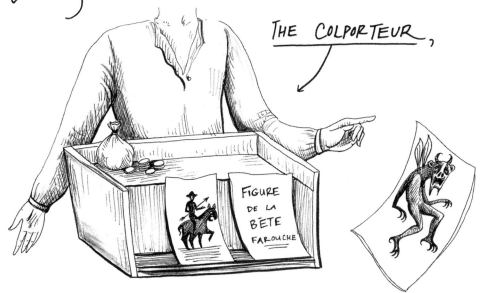

FIGURE
DE LA
BÊTE
FAROUCHE

The man who knew how to introduce

GHOST STORIES & tales of chivalry

into the servants' quarters in the cities

& the peasants' cottages in the country.

To a certain extent he must have
been able to become part of the stories
he was telling.

Not as the HERO, of course, not as
the BANISHED PRINCE or KNIGHT ERRANT,
but perhaps the ambiguous OLD MAN—
~ warner or seducer ?

LET US NOT FORGET

that books were originally OBJECTS for use — indeed a means of SUBSISTENCE.

They were DEVOURED.

Let us use them to study novels from the point of view of their food chemistry!

STORIES ARE INTERESTING ENOUGH IN THEMSELVES, but they become even more so when the SAME SPIRIT is expressed GRAPHICALLY & COLORFULLY through *Illustration.*

If only we had more such pictures!

The very principle of such illustrations testifies to the close connection between *Reader & Story*

THE WORK of ART IN THE AGE of MECHANICAL REPRODUCTION

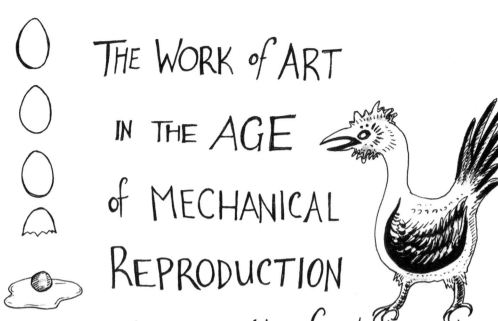

In principle, a work of art has always been reproducible. Man-made artifacts could always be imitated by man. Mechanical reproduction of a work of art, however, represents something NEW.

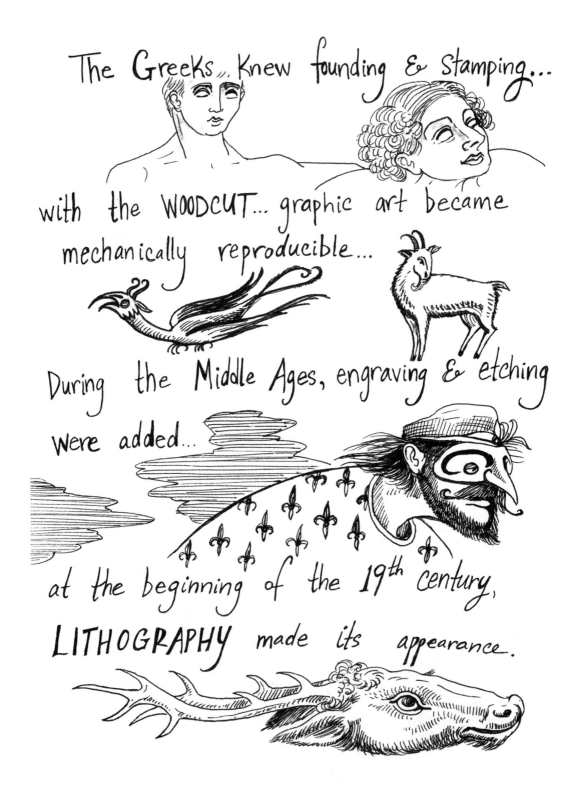

The Greeks knew founding & stamping...

with the WOODCUT... graphic art became mechanically reproducible...

During the Middle Ages, engraving & etching were added...

at the beginning of the 19th century, LITHOGRAPHY made its appearance.

LITHOGRAPHY enabled graphic art
to illustrate
EVERY DAY LIFE...

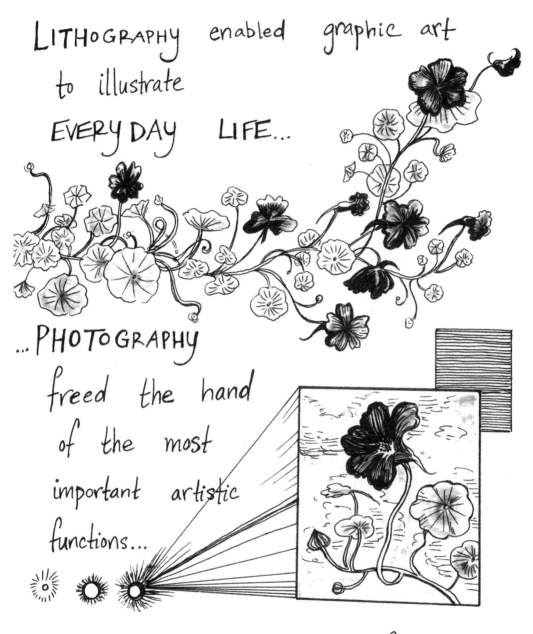

...PHOTOGRAPHY
freed the hand
of the most
important artistic
functions...

The technical reproduction of SOUND
was tackled at the end of the last century.

In the case of the ART OBJECT,
a most sensitive
NUCLEUS —
its authenticity —
is the essence of all that is
transmissible from its beginning...

The ART OBJECT'S
HISTORICAL TESTIMONY

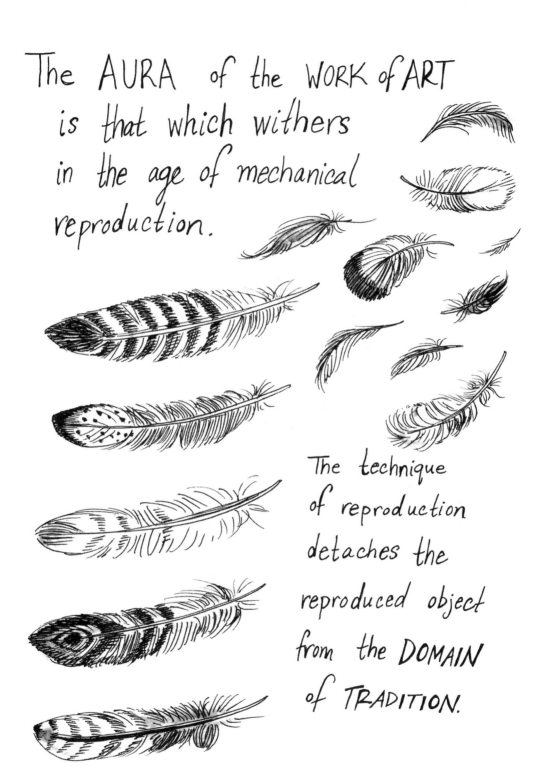

The AURA of the WORK of ART is that which withers in the age of mechanical reproduction.

The technique of reproduction detaches the reproduced object from the DOMAIN of TRADITION.

The uniqueness of a work of art is inseparable from its being imbedded in the FABRIC of TRADITION, which is ALIVE and extremely changeable.

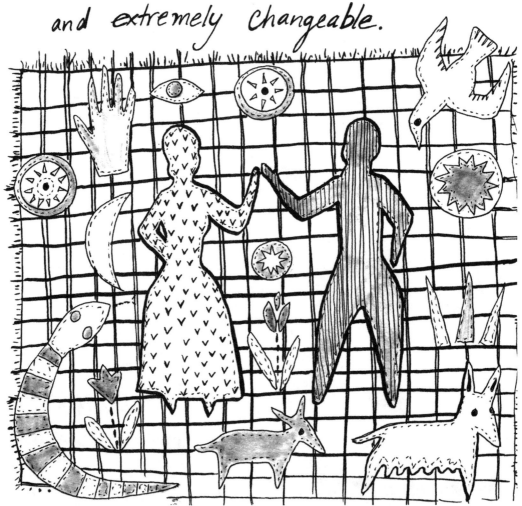

CULT VALUE:

Artistic production begins with ceremonial objects destined to serve in a CULT.

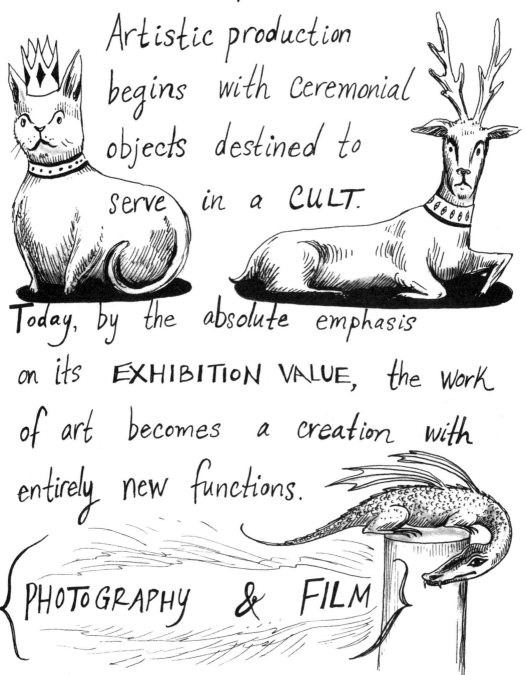

Today, by the absolute emphasis on its **EXHIBITION VALUE**, the work of art becomes a creation with entirely new functions.

{ PHOTOGRAPHY & FILM }

The film industry is trying
hard to spur the interest
of the masses through
illusion — promoting SPECTACLES
& DUBIOUS speculations.

MAGICIAN & SURGEON,
PAINTER & CAMERAMAN—

The painter maintains in his work a natural distance from reality,

A TOTAL PICTURE

The cameraman penetrates deeply into its web.

MULTIPLE FRAGMENTS which are assembled under a new LAW

Mechanical reproduction of ART
changes the reaction of
the masses toward art.

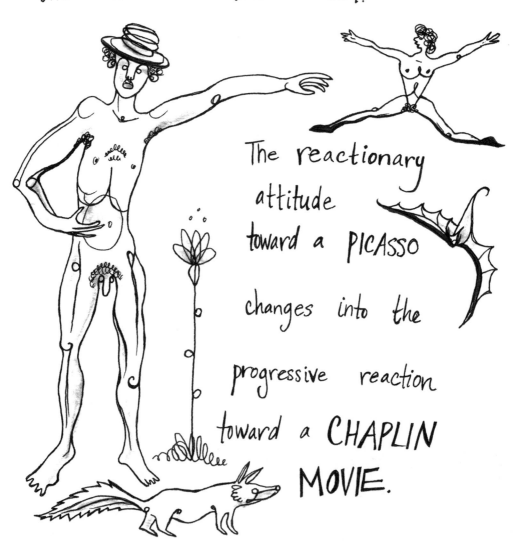

The reactionary
attitude
toward a PICASSO

changes into the

progressive reaction

toward a CHAPLIN
MOVIE.

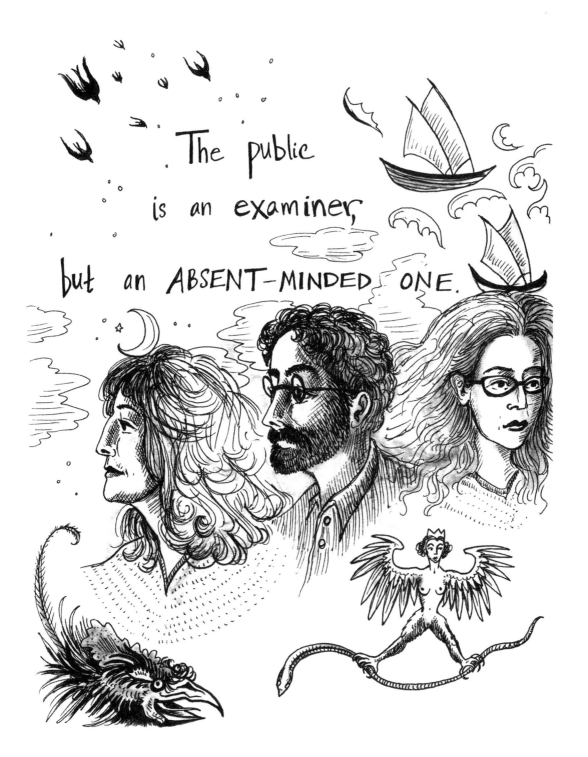

The public is an examiner, but an ABSENT-MINDED ONE.

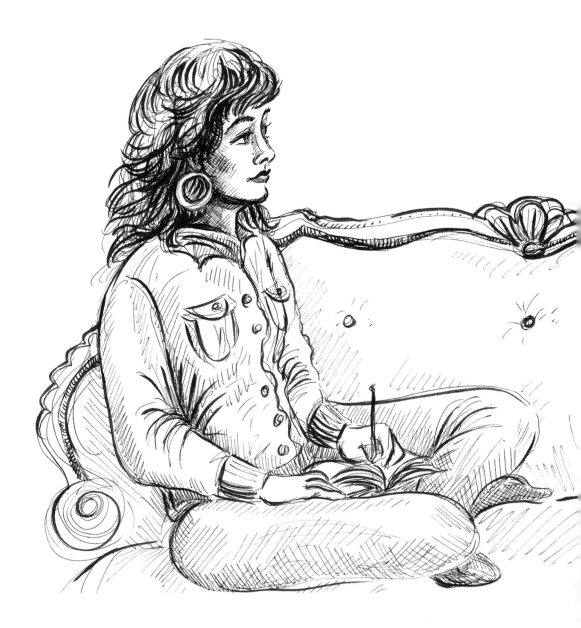

The DEEPEST SOLITUDE
IS THAT of the IDEAL HUMAN BEING

IN RELATION TO THE IDEA
which destroys what is human about him.
{ KNOWLEDGE COMES ONLY in LIGHTNING
FLASHES. The text is the long roll
of THUNDER that follows. }

III.

UNPACKING
MY LIBRARY

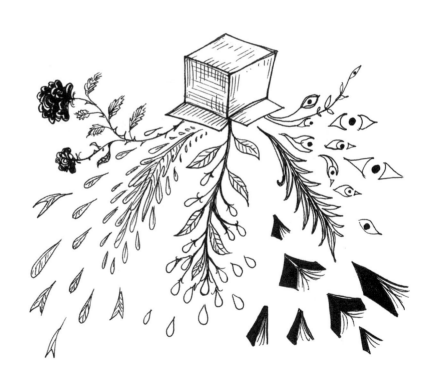

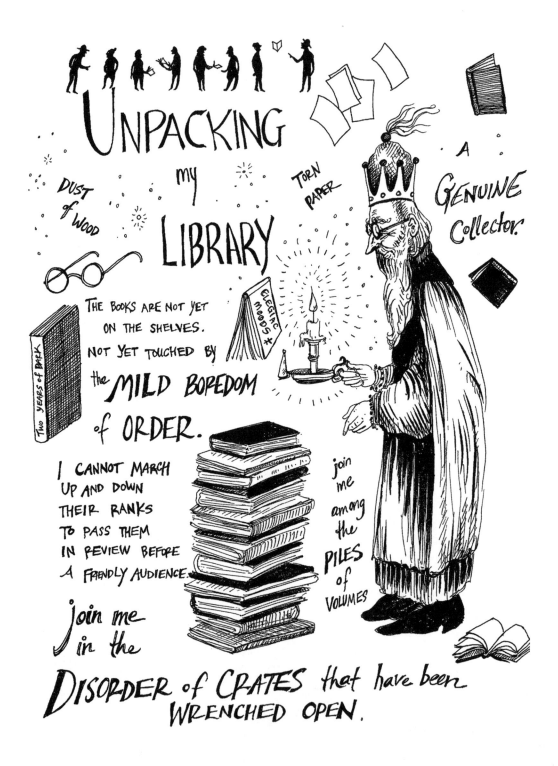

UNPACKING
my
LIBRARY

DUST of WOOD

TORN PAPER

A GENUINE Collector.

ELEGIAC MOODS

Two YEARS of BARK

THE BOOKS ARE NOT YET ON THE SHELVES. NOT YET TOUCHED BY the MILD BOREDOM of ORDER.

I CANNOT MARCH UP AND DOWN THEIR RANKS TO PASS THEM IN REVIEW BEFORE A FRIENDLY AUDIENCE.

join me among the PILES of VOLUMES

join me in the

DISORDER of CRATES that have been WRENCHED OPEN.

once you have approached the MOUNTAINS
of cases in order to mine the BOOKS
from them and bring them to
the *light of Day,* or rather,
of NIGHT,

what *memories CROWD IN
UPON YOU!*

I had started at NOON,

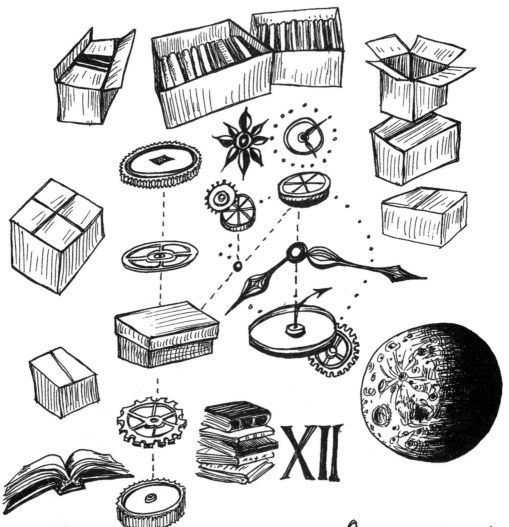

and it was MIDNIGHT before I had
worked my way to the last cases.

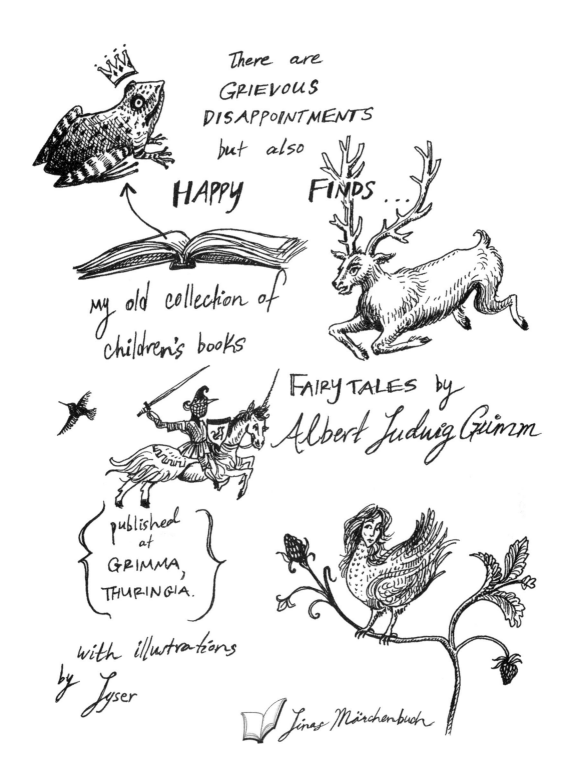

There are GRIEVOUS DISAPPOINTMENTS but also

HAPPY FINDS ...

my old collection of children's books

FAIRY TALES by

Albert Ludwig Grimm

published at GRIMMA, THURINGIA.

with illustrations by Lyser

Linas Märchenbuch

Two ALBUMS with stick-in pictures
which my mother pasted in as a
CHILD and which I INHERITED,

they are the SEEDS of a COLLECTION
of CHILDREN'S BOOKS which is growing
steadily, though no longer in my
GARDEN.

for years, my library consisted of no more than TWO SHELVES which increased only by INCHES EACH YEAR...

now, we reach the WIDE HIGHWAY of BOOK ACQUISITION, I HAVE MADE MY MOST MEMORABLE PURCHASES on TRIPS, as a TRANSIENT.

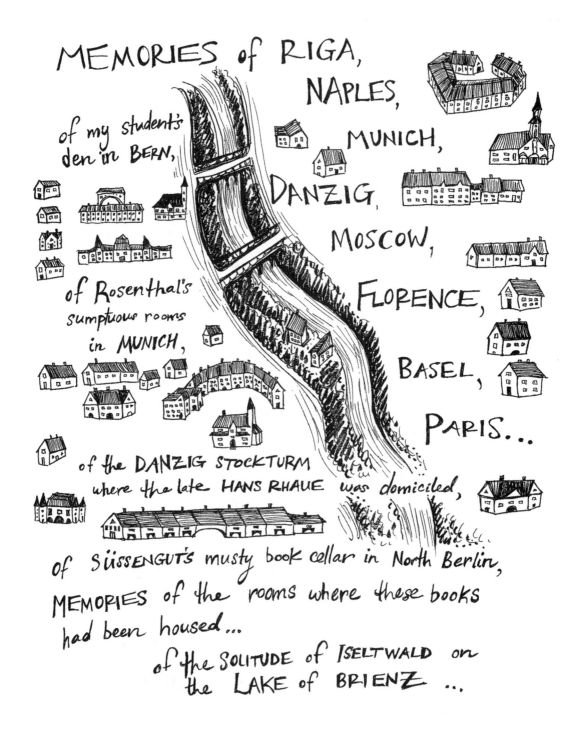

MEMORIES of RIGA,
NAPLES,
MUNICH,
of my student's
den in BERN,
DANZIG,
MOSCOW,
FLORENCE,
of Rosenthal's
sumptuous rooms
in MUNICH,
BASEL,
PARIS...

of the DANZIG STOCKTURM
where the late HANS RHAUE was domiciled,

of SÜSSENGUT'S musty book cellar in North Berlin,
MEMORIES of the rooms where these books
had been housed...
of the SOLITUDE of ISELTWALD on
the LAKE of BRIENZ ...

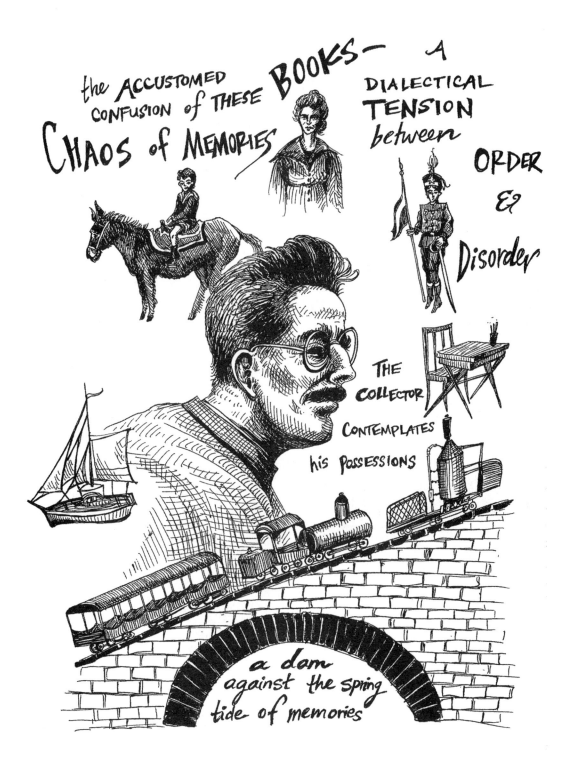

the ACCUSTOMED CONFUSION of THESE BOOKS — A DIALECTICAL TENSION between

CHAOS of MEMORIES

ORDER & Disorder

THE COLLECTOR CONTEMPLATES his POSSESSIONS

a dam against the spring tide of memories

Qualities of a Collection:

DATES

PLACE NAMES

FORMATS

PREVIOUS OWNERS

BINDINGS

a harmonious whole

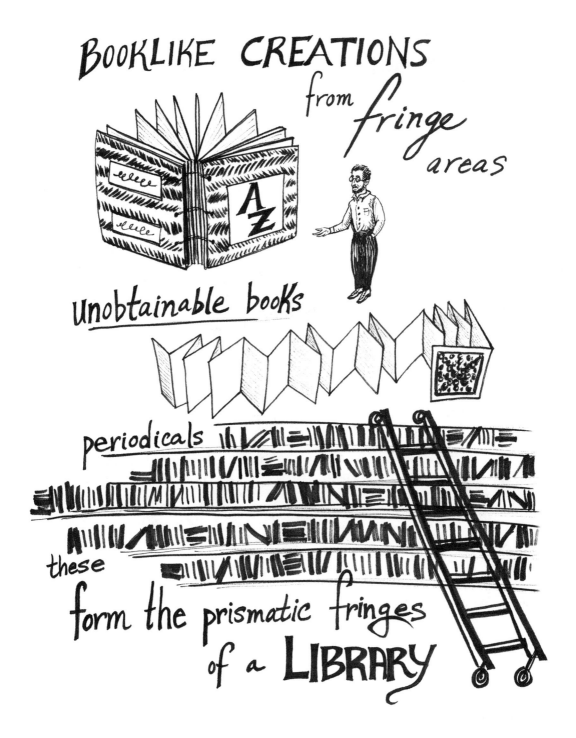

BOOKLIKE CREATIONS
from fringe areas

unobtainable books

periodicals

these

form the prismatic fringes
of a LIBRARY

THE COLLECTOR'S DEEPEST DESIRE —
TO RENEW the OLD WORLD

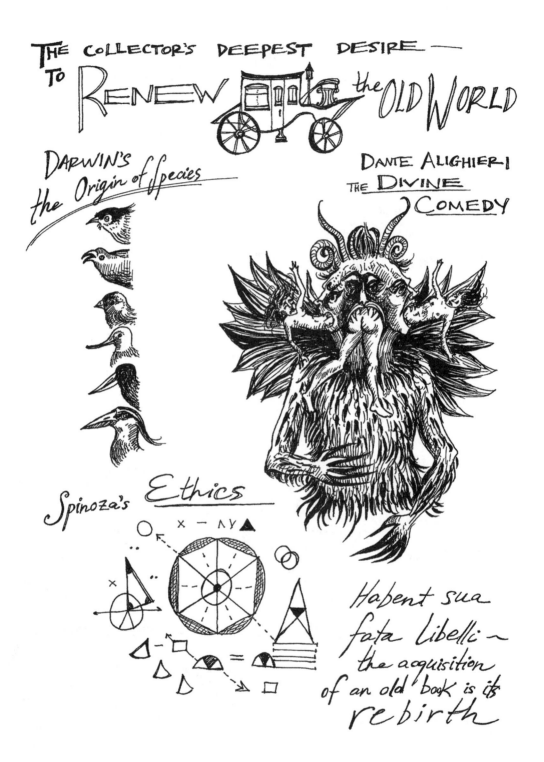

DARWIN'S the Origin of Species

DANTE ALIGHIERI THE **DIVINE** COMEDY

Spinoza's **Ethics**

Habent sua fata libelli — the acquisition of an old book is its *rebirth*

the ANGLE of a REAL COLLECTOR is

WHIMSICAL

ANATOLE FRANCE

A PHILISTINE

"and you have read all of these books, Monsieur France?"

"Not one-tenth of them, I don't suppose you use your Sèvres China every day?"

AT AUCTION,

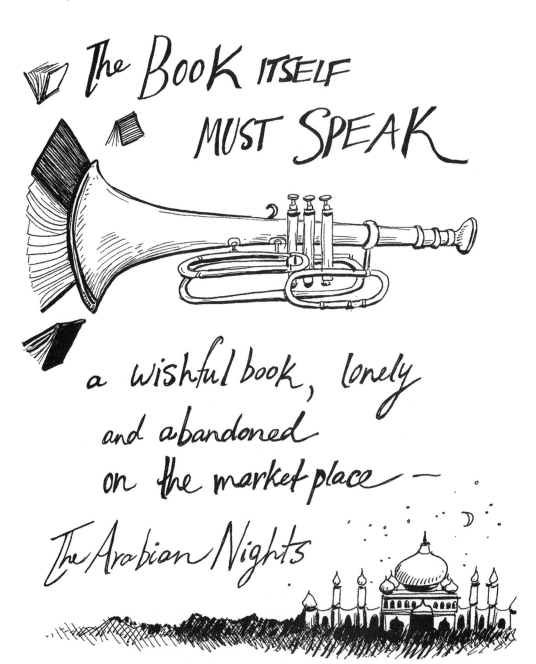

The BOOK ITSELF
MUST SPEAK

a wishful book, lonely
and abandoned
on the market place —

The Arabian Nights

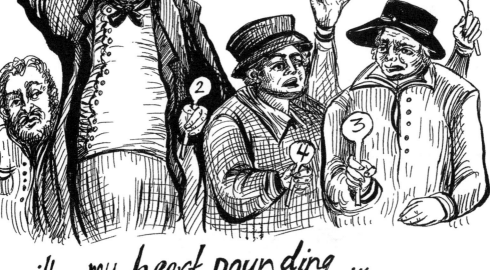

THE FAMOUS MUNICH Collector BARON VON SIMOLIN

RIVAL BIDDERS

With my heart pounding ...
I bid a higher amount.
THREE BANGS of the AUCTIONEER'S GAVEL, for a student like me the sum was CONSIDERABLE.

a memento of my MOST EXCITING
EXPERIENCE at AUCTION :

Balzac's
Peau de Chagrin, 1838, Paris

time — 1915
place — RÜMANN AUCTION
dealer — Emil Hirsch
original owner — Papeterie Flanneau

Place de la
Bourse

with steel engravings by the foremost
French graphic artist and executed
by the foremost engravers ...

each illustration printed separately
on India paper.

the most PROFOUND ENCHANTMENT...
for a true collector the whole BACKGROUND
of an item adds to a magic encyclopedia
whose quintessence is the fate of his
OBJECT.

a MAGIC CIRCLE

the THRILL of ACQUISITION
THE PERIOD of the REGION

the CRAFTSMANSHIP ➤○◄

the FORMER OWNERSHIP

the pedestal, the frame, the lock of property

O, BLISS of the COLLECTOR,
BLISS of the MAN of LEISURE!
Not that the books come alive in him,
it is HE who LIVES in THEM.

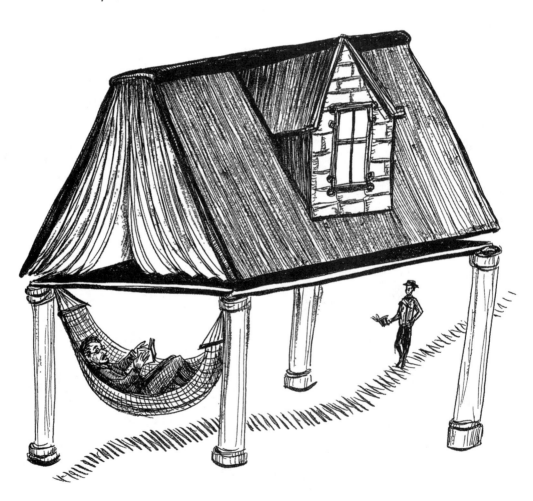

I have erected one of his dwellings, with BOOKS as BUILDING STONES, BEFORE you

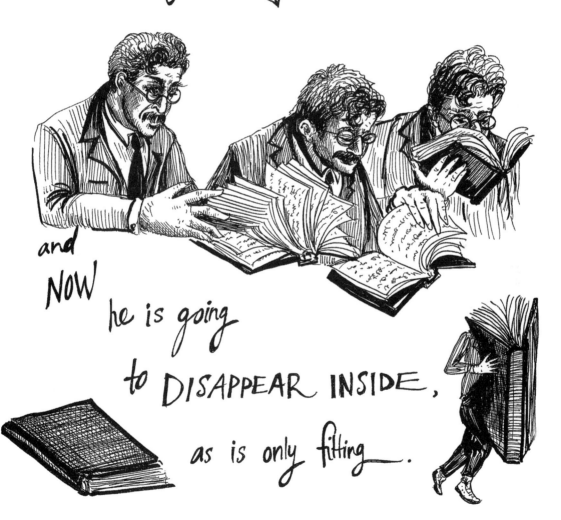

and NOW he is going to DISAPPEAR INSIDE, as is only fitting.

IV.
ATHENAEUM OF THE IMAGINATION

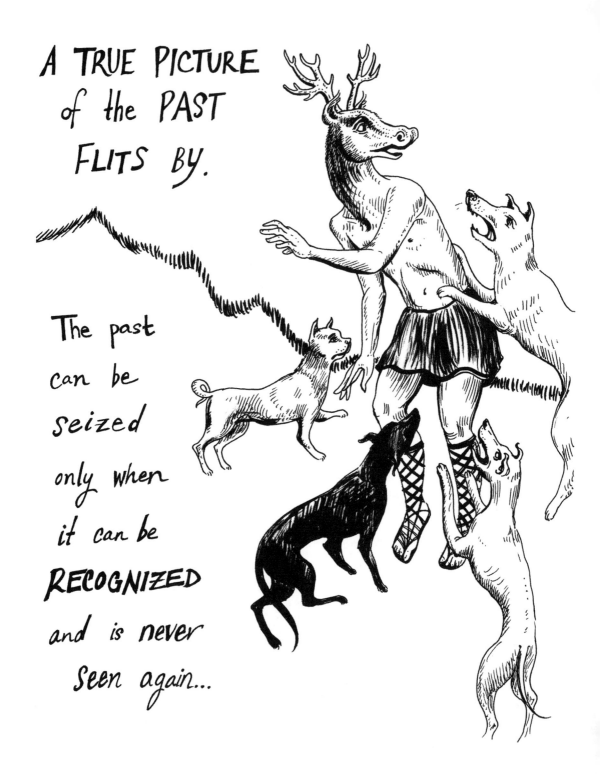

A TRUE PICTURE of the PAST FLITS BY.

The past can be seized only when it can be RECOGNIZED and is never seen again...

Look to the margin of the
 GREAT STONE ROAD,
see one standing in immutable calm,
SOLITARY, at a distance from
the road of life.

His penetrating gaze is directed
now within, now boldly
upward to us in the light,
and NOW, ranging wide,
upon the throng.

His hand writes down
 LINES ETERNAL ———

See and know this one:
 IT IS THE POET.

Why is there anything in the world?

WHY THE WORLD?

The ocean and its continents had little advantage over my washstand set while the moon still shone. Of my own existence, nothing was left except the dregs of its abandonment.

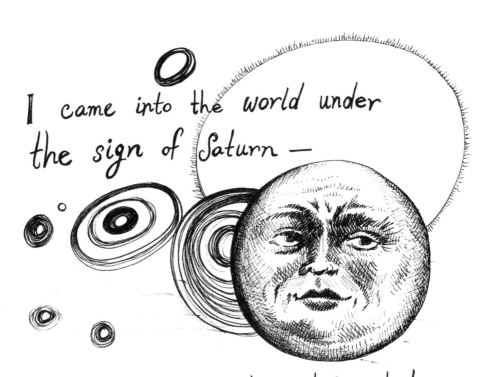

I came into the world under
the sign of Saturn —

the star of the slowest evolution,
the planet of **detours** and delays.

MODERN MAN can be touched
by a PALE SHADOW...

ON SOUTHERN
MOONLIT
NIGHTS
in which he feels,
ALIVE WITHIN HIMSELF,
MIMETIC FORCES
that he had
thought

Long

since

dead.

EVERY GREAT MAN HAS ONLY ONE CONVERSATION,

at whose margins

^A SILENT GREATNESS WAITS...

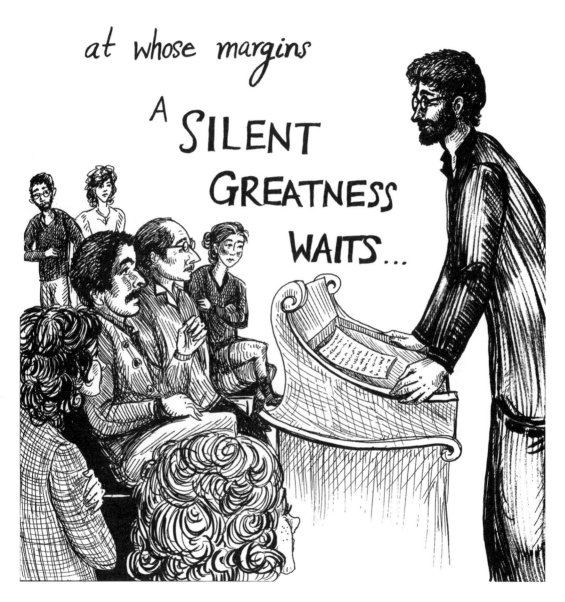

SILENCE

has long reigned
in the upholstered rooms.

HERE
HE
CAN
MAKE
SOME
NOISE.

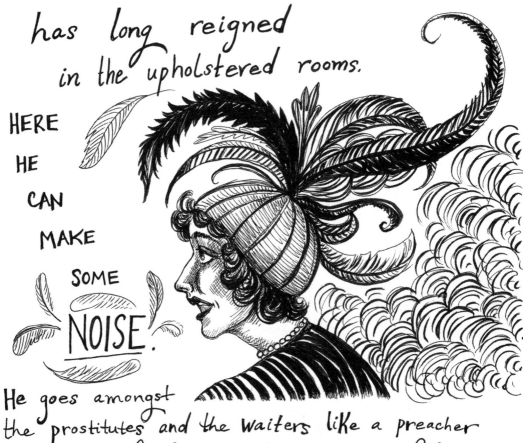

He goes amongst
the prostitutes and the waiters like a preacher
among the faithful—he, the convert of his
latest conversation. Now he has mastered two languages.
QUESTION and ANSWER.

The unproductive person ...
saves himself by fleeing into
the erotic.

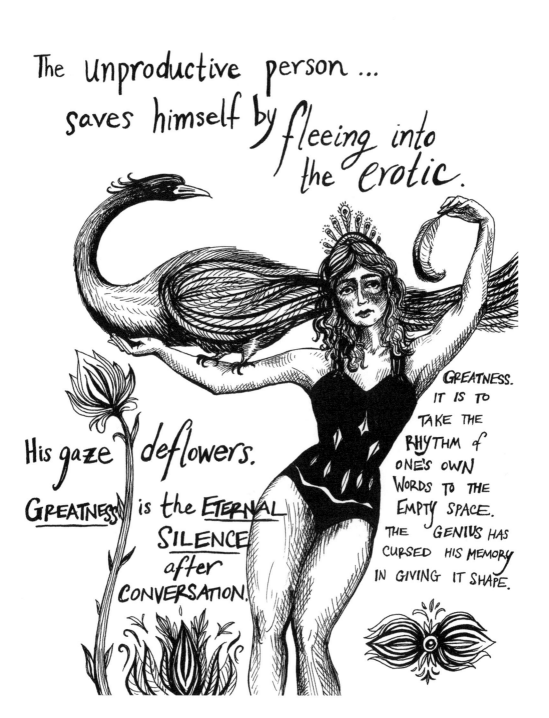

His gaze deflowers.

GREATNESS is the ETERNAL
SILENCE
after
CONVERSATION.

GREATNESS.
IT IS TO
TAKE THE
RHYTHM of
ONE'S OWN
WORDS TO THE
EMPTY SPACE.
THE GENIUS HAS
CURSED HIS MEMORY
IN GIVING IT SHAPE.

The DIRTY JOKE TRIUMPHS —
the WORLD WAS BUILT of WORDS.

WHEN MEN SPEAK, THEIR TALK BECOMES DESPAIR; IT RESOUNDS IN THE MUTED SPACE & BLASPHEMES AGAINST GREATNESS.

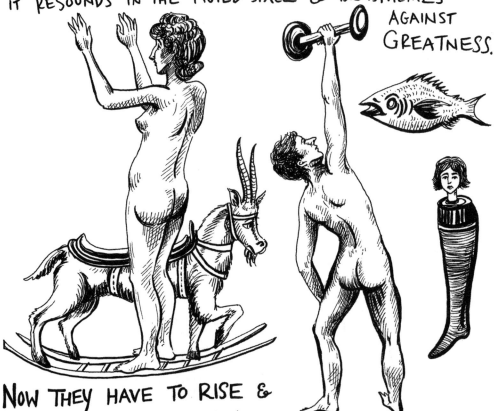

NOW THEY HAVE TO RISE & SMASH THEIR BOOKS & MAKE OFF WITH A WOMAN, SINCE OTHERWISE THEY WILL SECRETLY STRANGLE THEIR SOULS. LAUGHING, REVELATION STANDS BEFORE THEM & COMPELS THEM TO FALL SILENT.

WORDS of the SAME GENDER COUPLE and INFLAME each-other with their secret attraction;

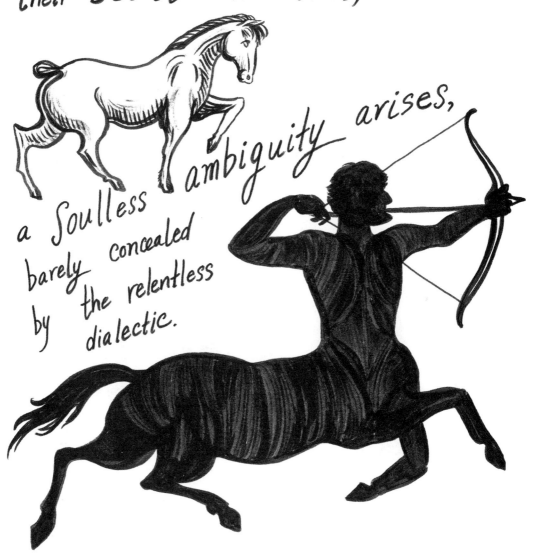

a soulless ambiguity arises, barely concealed by the relentless dialectic.

The RELATION between MAN & WOMAN

contains LOVE symbolically. Its actual content may be called GENIUS

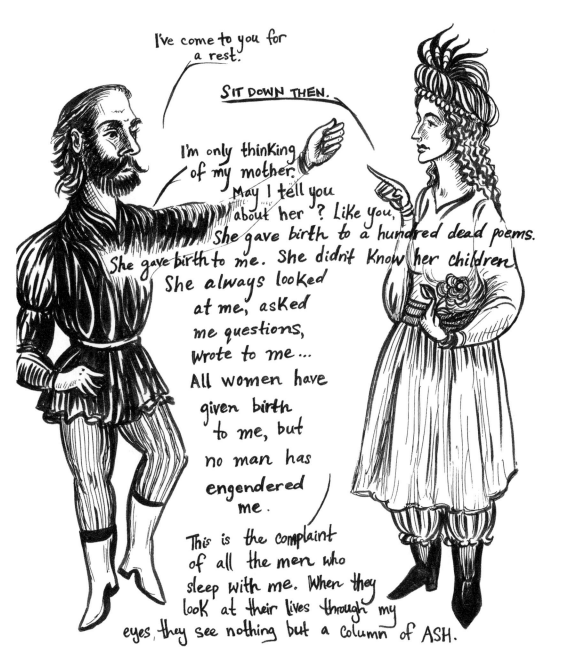

THE GENIUS & THE PROSTITUTE.

I've come to you for a rest.

SIT DOWN THEN.

I'm only thinking of my mother. May I tell you about her? Like you, she gave birth to a hundred dead poems. She gave birth to me. She didn't know her children. She always looked at me, asked me questions, wrote to me... All women have given birth to me, but no man has engendered me.

This is the complaint of all the men who sleep with me. When they look at their lives through my eyes, they see nothing but a column of ASH.

THE WOMAN IS GUARDIAN of ALL CONVERSATIONS.
WHEN MEN SPEAK, THEIR TALK BECOMES DESPAIR,
IT RESOUNDS IN THE HOLLOW SPACE, and,
BLASPHEMING, CLUTCHES AT GREATNESS.

TWO MEN
ARE ALWAYS
TROUBLEMAKERS;
THEY FINISH
BY RESORTING
TO TORCH
&
AXE.

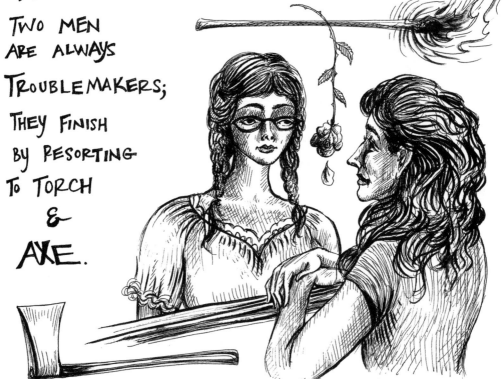

THEY NULLIFY THE WOMAN WITH THEIR SMUTTY
JOKES; THE PARADOX VIOLATES GREATNESS.

HOW DID SAPPHO
 & HER
 WOMEN FRIENDS
 TALK AMONG
 THEMSELVES?

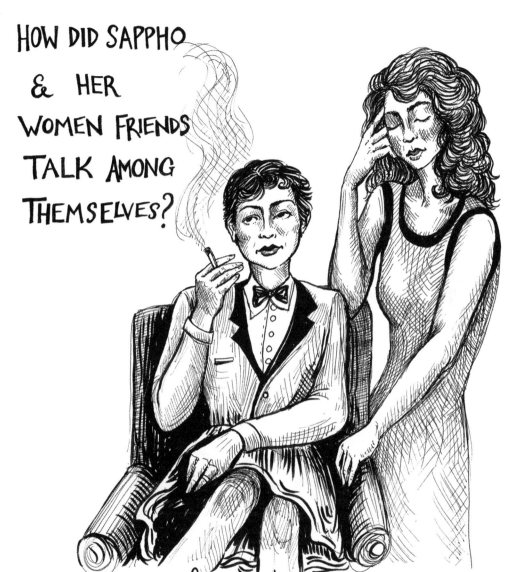

What they listen for are the UNSPOKEN WORDS.
They bring their bodies close and caress one another.
Their conversation has freed itself from subject & language

The SILENT WOMEN are speakers
of what has been spoken.
They step out of the circle,
they alone recognize the perfection
of its
ROUNDNESS.

From the
FRONTIER of SILENT DELIGHT... in a great burst of
LIGHT, the youth of mysterious conversation arose.
ESSENCE was RADIANT.

CONVERSATION ON LOVE.

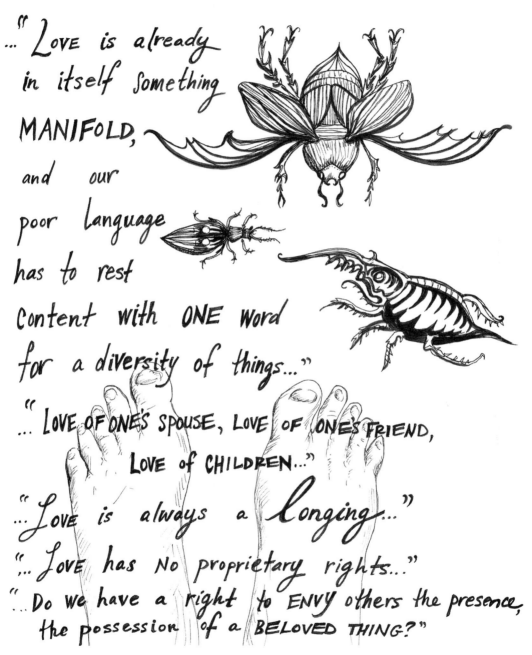

"... LOVE is already
in itself something
MANIFOLD,
and our
poor language
has to rest
content with ONE word
for a diversity of things..."

"... LOVE OF ONE'S SPOUSE, LOVE OF ONE'S FRIEND,
LOVE of CHILDREN..."

"... Love is always a longing..."

"... Love has NO proprietary rights..."

"... Do we have a right to ENVY others the presence,
the possession of a BELOVED THING?"

"Love BETTERS. Whoever possesses love must become better. Here are all Lovers— mothers and friends. For they wish to see the beloved PROSPER."

"Then only good people can love..."

"Not so— who is *good*? But truly— the only people who can love are those who WANT to be good."

"And also want the beloved to be good."

"*IT'S THE SAME THING.*"

We are TRULY IN A HOUSE WITHOUT WINDOWS, A ROOM WITHOUT A WORLD. Flights of stairs lead up and down, marble. Here TIME IS CAPTURED. Around this house, we know, are fluttering all the merciless realities that have been expelled. The poets with their BITTER SMILES,

THE SAINTS,

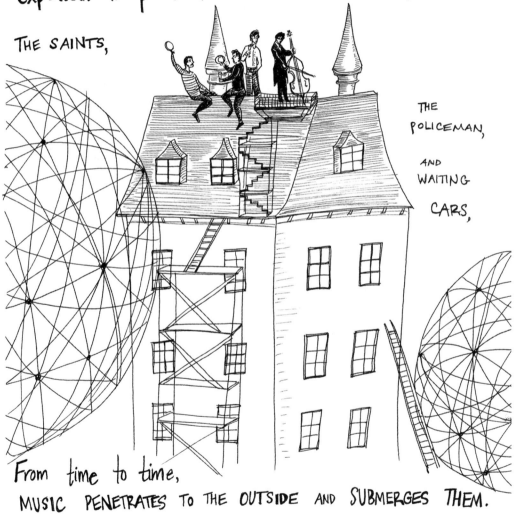

THE POLICEMAN, AND WAITING CARS,

From time to time, MUSIC PENETRATES TO THE OUTSIDE AND SUBMERGES THEM.

How deeply veiled the girls' faces are; their eyes are SECLUDED NESTS of the UNCANNY

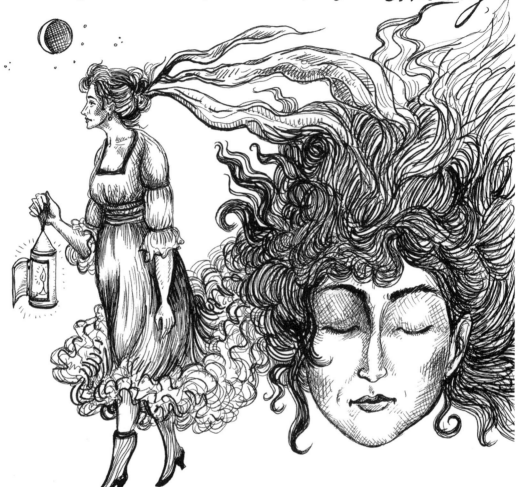

of DREAMS, quite inaccessible, LUMINOUS from sheer light—that shines from beneath the curtain when the violins tune up in an orchestra.

Our bodies make careful contact, we do not rouse one another from our dreams, or call one another homeward into the darkness — out of the night of night, which is not day.

HOW WE LOVE ONE ANOTHER!

How we safeguard our NAKEDNESS! We have bound it in gay colors, masks, withholding nakedness and promising it.

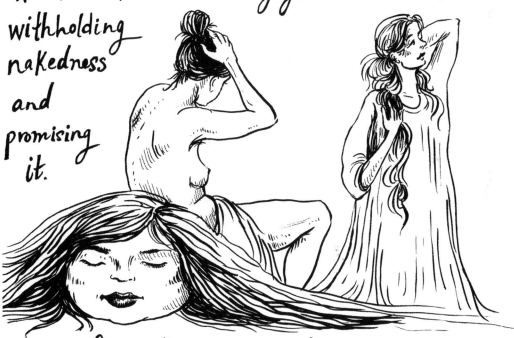

In all of us there is something MONSTROUS to keep QUIET about.

When did NIGHT EVER ATTAIN BRIGHTNESS and become RADIANT, if NOT HERE?

When was time OVERCOME? Who knows whom we will meet at this hour? The music transports our thoughts; our eyes reflect the friends around us, how we are all moving, bathed in NIGHT.

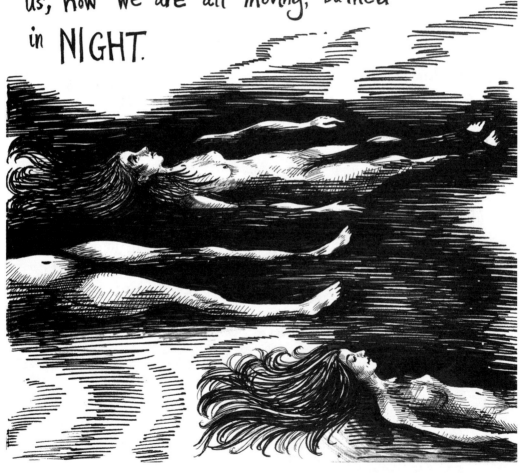

There is HAPPINESS—such as could arouse envy in us—only in the air we have breathed, among people we have talked to...

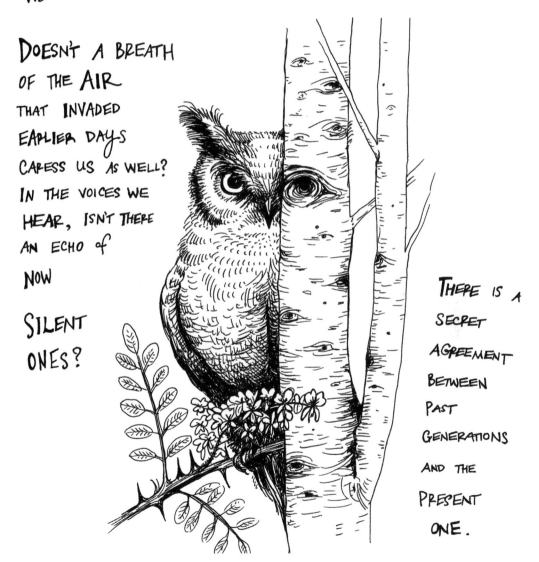

DOESN'T A BREATH
OF THE AIR
THAT INVADED
EARLIER DAYS
CARESS US AS WELL?
IN THE VOICES WE
HEAR, ISN'T THERE
AN ECHO OF
NOW

SILENT
ONES?

THERE IS A
SECRET
AGREEMENT
BETWEEN
PAST
GENERATIONS
AND THE
PRESENT
ONE.

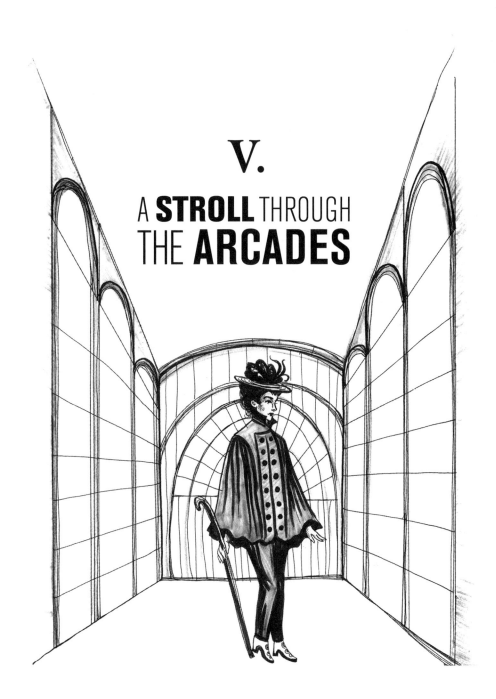

V.

A **STROLL** THROUGH THE **ARCADES**

PARIS ARCADES · SKETCHES

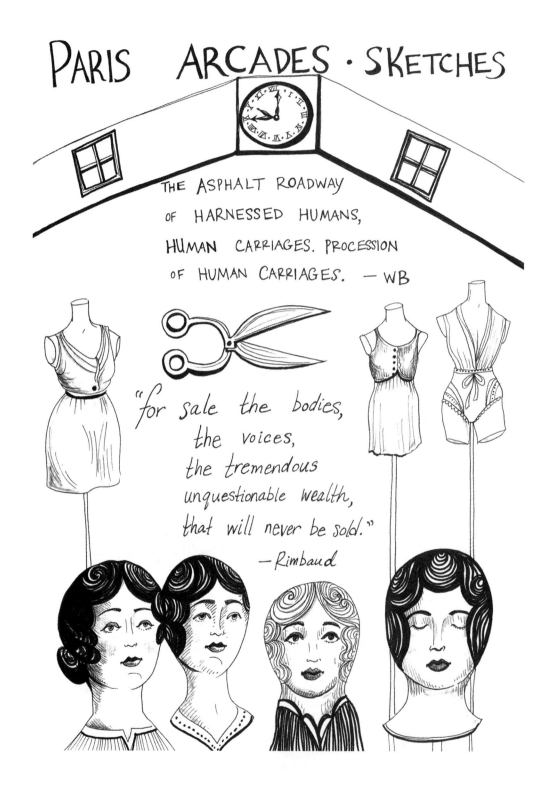

THE ASPHALT ROADWAY
OF HARNESSED HUMANS,
HUMAN CARRIAGES. PROCESSION
OF HUMAN CARRIAGES. — WB

"for sale the bodies,
 the voices,
 the tremendous
 unquestionable wealth,
 that will never be sold."
 — Rimbaud

WORLD of PARTICULAR SECRET AFFINITIES:

PALM TREES & FEATHER DUSTER,

HAIRDRYER & VENUS de MILO,

CHAMPAGNE BOTTLES,

PROSTHESES & LETTER-WRITING MANUALS

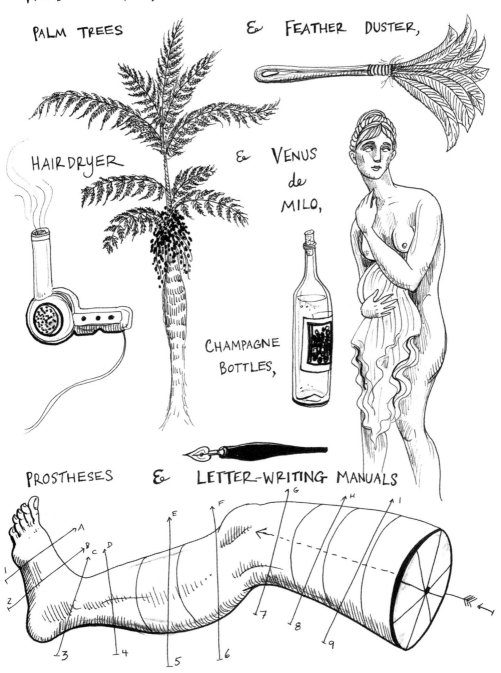

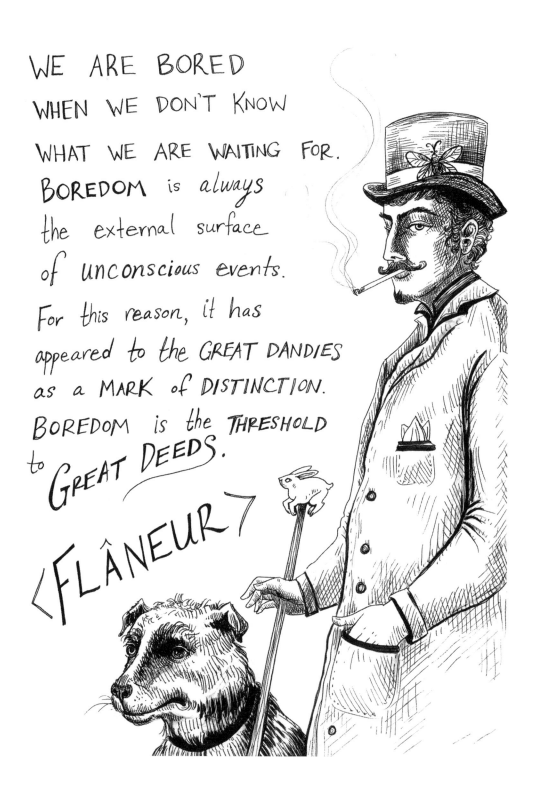

WE ARE BORED
WHEN WE DON'T KNOW
WHAT WE ARE WAITING FOR.
BOREDOM is always
the external surface
of unconscious events.
For this reason, it has
appeared to the GREAT DANDIES
as a MARK of DISTINCTION.
BOREDOM is the THRESHOLD
to GREAT DEEDS.

〈FLÂNEUR〉

BOREDOM is a warm gray fabric
lined on the inside with the most
LUSTROUS & COLORFUL of SILKS.
In this fabric we wrap ourselves
when we dream.
We are at home
in the

Arabesques

of its lining.

Flânerie is the rhythmics
of this slumber.

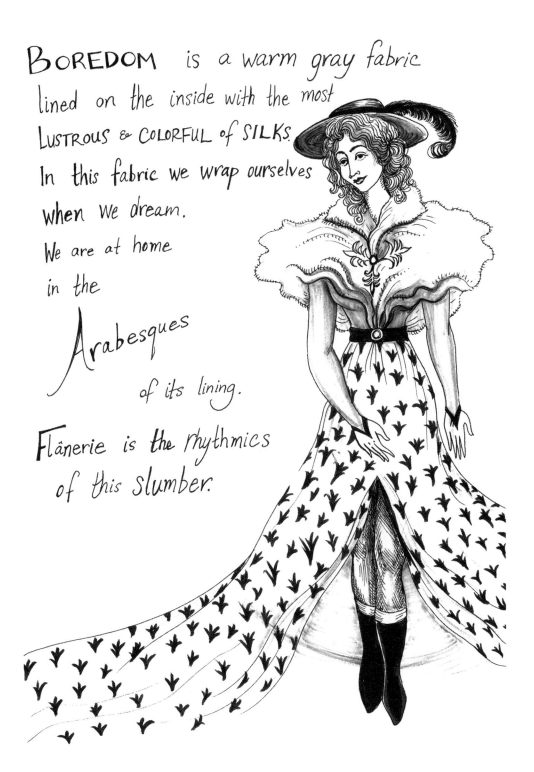

DUST & STIFLED PERSPECTIVE —

PLUSH as dust collector.

Mystery of dust motes

PLAYING in the sunlight

Dust & the "BEST" ROOM...

Other arrangements to stir

up dust:
the TRAINS
of
DRESSES

BOREDOM, ETERNAL RETURN.
The WEATHER

NOTHING BORES THE ORDINARY MAN MORE THAN THE COSMOS.

Only someone who has grown up in the city can appreciate its rainy weather, which slyly sets one dreaming back to EARLY CHILDHOOD.

The mere narcotizing effect which cosmic forces have on shallow and brittle personality...

{ L'Ennui }

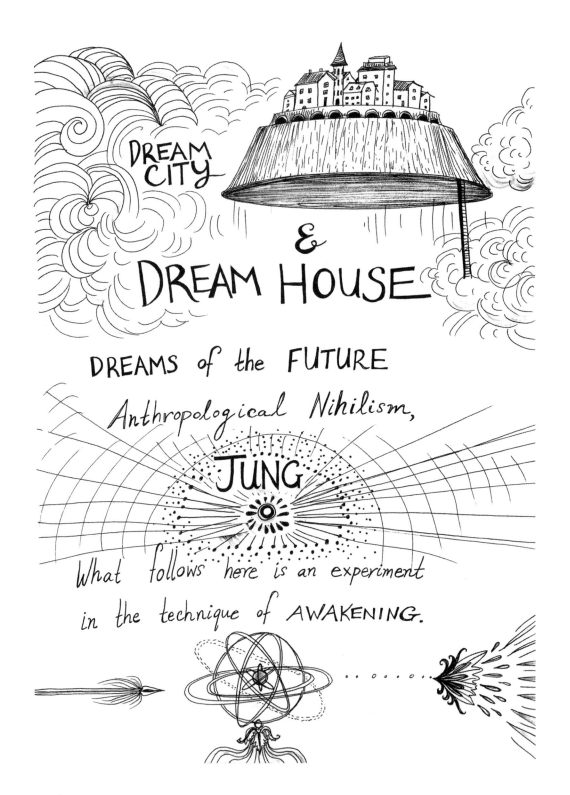

DREAM CITY

& DREAM HOUSE

DREAMS of the FUTURE

Anthropological Nihilism,

JUNG

What follows here is an experiment
in the technique of AWAKENING.

As the SLEEPER, like the MADMAN,
sets out on the macrocosmic journey,
through his own body, the NOISES
& FEELINGS of his insides generate
illusion or dream imagery,

likewise the DREAMING COLLECTIVE,
through THE ARCADES,
communes with its own INSIDES.

We must follow in its wake
so as to expound
the nineteenth century—
in fashion & advertising,
in building & politics—
as the OUTCOME
of its DREAM VISIONS.

The street that runs through houses is the track of a ghost through the walls.

The dread of doors that won't close is something everyone knows from dreams. The PATH WE TRAVEL through the ARCADES is fundamentally just

A GHOST WALK, on which DOORS GIVE WAY and WALLS YIELD.

The forms of appearance taken
by the dream collective
in the nineteenth century
allow us to recognize the SEA
on which we navigate
& the shore from which
we push off.

The CRITIQUE of the 19ᵗʰ century,
not of its mechanism
& CULT of machinery
but of its NARCOTIC
HISTORICISM,
its passion for MASKS.

Capitalism was a natural phenomenon
with which a new dream-filled sleep came
over Europe, and, through it, a reactivation
of MYTHIC FORCES.

REMEMBERING & AWAKENING

ARE MOST INTIMATELY RELATED.

AWAKENING IS NAMELY the Dialectical, Copernican turn of remembrance.

The nineteenth century
is a SPACETIME ≪ZEITRAUM≫
a dreamtime ≪ZEIT-TRAUM≫
in which the individual consciousness
secures itself in REFLECTING,
while the collective consciousness
sinks into EVER DEEPER SLEEP.

VI.
A **COLLECTION** OF **DREAMS** AND **STORIES**

Spring's Hideaway

IN A CORNER, WHERE THE FENCES PRESS CLOSE &

A HIGH RED WALL LOOMS DARK

& BRUTAL, a pear tree stands;

... now and again

 a mild wind blows

 and blossoms float

 down
 into
 the
 garden.

THE DIARY

THIS UNFATHOMABLE BOOK of a LIFE NEVER
LIVED, A BOOK of a LIFE IN WHOSE TIME
EVERYTHING WE EXPERIENCED
INADEQUATELY IS TRANSFORMED
AND PERFECTED

IT IS A BOOK of TIME: DAYBOOK, BOOK of DAYS.

THIS IS THE SHAPE of LOVE

IN THE DIARY —

WE ENCOUNTER IT IN THE LANDSCAPE
BENEATH A VERY BRIGHT SKY.

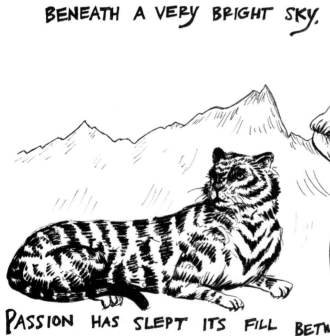

PASSION HAS SLEPT ITS FILL BETWEEN US.

THE LOVER.

I WAS OUT WITH MY GIRLFRIEND.
WE HAD UNDERTAKEN SOMETHING BETWEEN
MOUNTAIN HIKING AND *Strolling...*

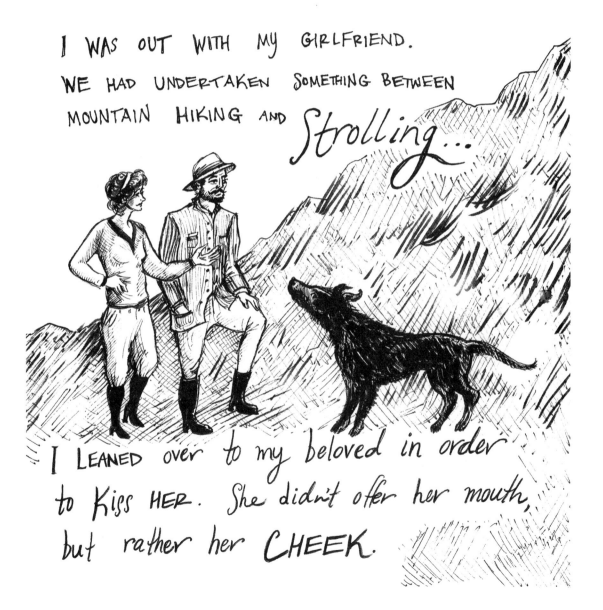

I LEANED over to my beloved in order
to KISS HER. She didn't offer her mouth,
but rather her CHEEK.

I KISSED HER, and noticed that this cheek was of IVORY and was permeated along its whole length by BLACK, ornately radiating VEINS,

Which struck me because of their BEAUTY.

sKetched into mobile dust

the memory of a wild, unworthy, indeed,

SHAMEFUL YOUNG LOVE

OLYMPIA

"every journey and every adventure must revolve around a woman, or at least a woman's name."

On rare occasions the diary emerges hesitantly from the immortality of its interval and WRITES ITSELF.

Thirsting for definition...

We plunge from NAKEDNESS to NAKEDNESS

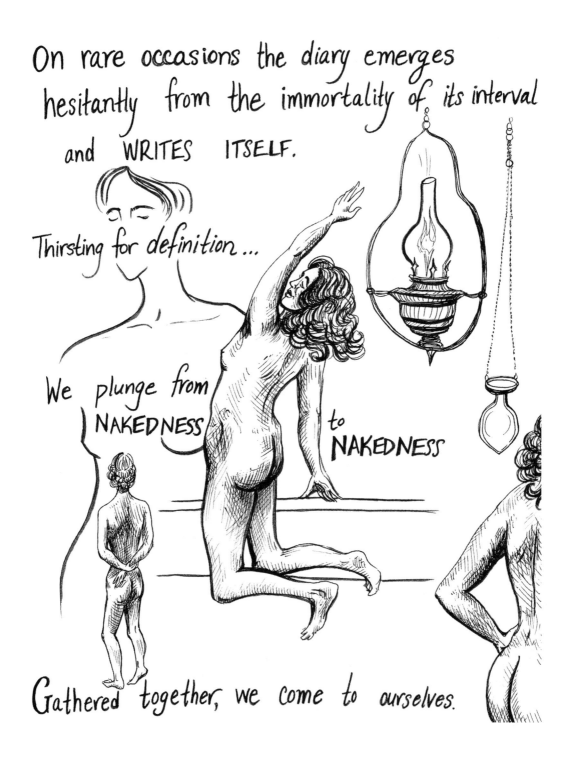

Gathered together, we come to ourselves.

120

Trembling, an "I" that we know only from our diaries stands on the brink of the IMMORTALITY INTO WHICH IT PLUNGES

IT IS INDEED TIME.

The believer writes in his DIARY. He writes it at intervals and will NEVER complete it, because HE WILL DIE. {memento mori}

DIARY — Pentecost. APRIL 11, 1911.

Everywhere in Germany now the fields are being tilled.

During the journey, I read Anna Karenina.

Traveling and reading — an existence between two new, instructive, and momentous realities.

when traveling, one should not wear one's worst clothes, because travel is an act of

INTERNATIONAL CULTURE: one steps out of one's PRIVATE EXISTENCE INTO THE PUBLIC.

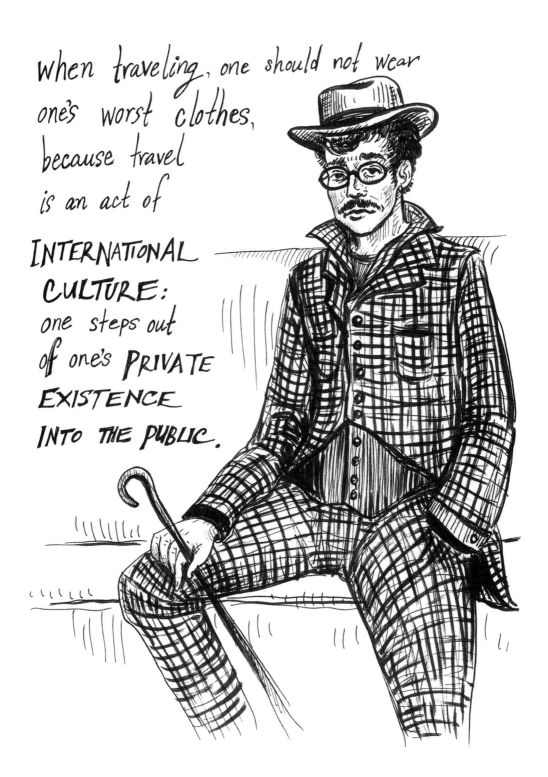

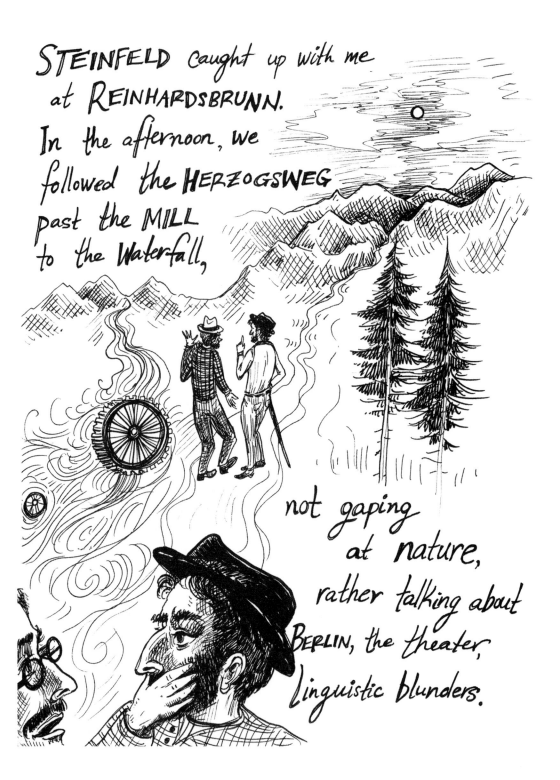

STEINFELD caught up with me at REINHARDSBRUNN. In the afternoon, we followed the HERZOGSWEG past the MILL to the Waterfall, not gaping at nature, rather talking about BERLIN, the theater, linguistic blunders.

NOVARUM RERUM CUPIDUS
(eager for new things)

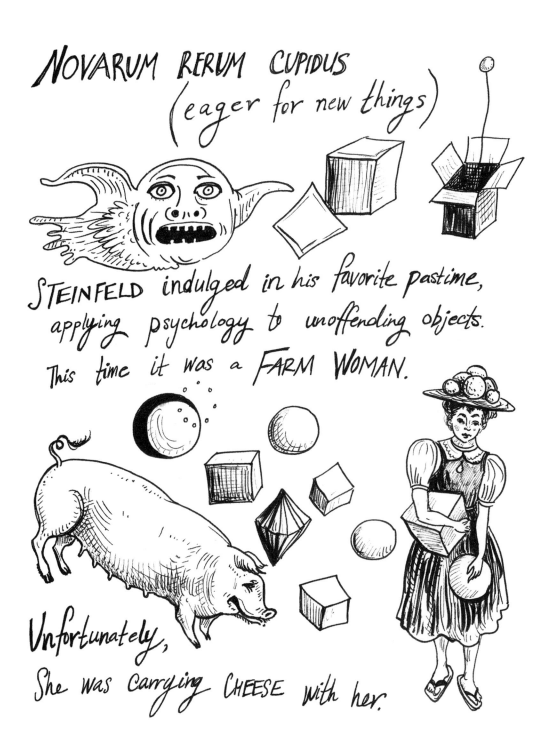

STEINFELD indulged in his favorite pastime, applying psychology to unoffending objects. This time it was a FARM WOMAN.

Unfortunately, She was carrying CHEESE with her.

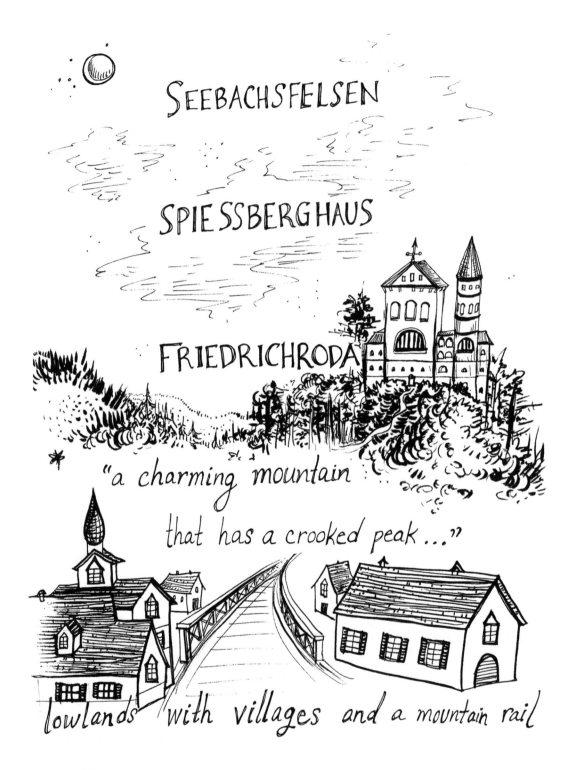

SEEBACHSFELSEN

SPIESSBERGHAUS

FRIEDRICHRODA

"a charming mountain

that has a crooked peak ..."

lowlands with villages and a mountain rail

126

Paths and meadows were wet, everything was wonderfully fresh.

The sunset was marvelous after the rain. Friedrichroda was veiled in mist that glistened in the sun; the woods were IRRADIATED with RED, and individual branches and tree trunks along the path were glowing.

April 12, 1911. Today is YONTEV.
I've just been reading the Haggadah.
...this evening I traveled back
in world history about
FIVE HUNDRED YEARS...

Rain and STORM
USHERED in
the FEAST
DAY.

OUTSIDE,
SPLENDID, LARGE SNOWFLAKES;
INSIDE,
foolish things were said about graphology.

OUTPOST SKIRMISHES with the SECOND UPPER MOLAR.

The TOOTH has DECREED an AMNESTY for the sake of a few BONBONS.

In other respects, too, it has behaved admirably.

Morning didn't happen because we convinced ourselves that we needn't rise before 9:15.

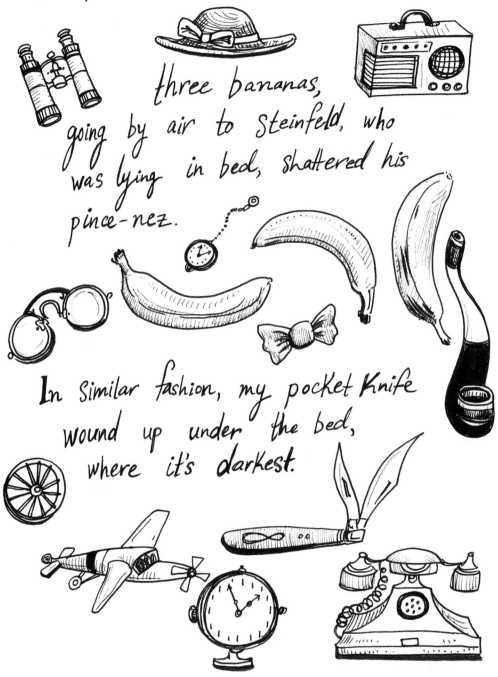

IN the afternoon there was a REVOLT of OBJECTS.

three bananas,
going by air to Steinfeld, who
was lying in bed, shattered his
pince-nez.

In similar fashion, my pocket knife
wound up under the bed,
where it's darkest.

130

I became interested in studying the few
TRULY LIVING STORIES that continue
to have an impact and are capable
of constant renewal. The ARCHIVE
of such stories is the DREAM,

as Freud taught us
to understand it

THE STORY of THE CACTUS HEDGE:

The first foreigner who came to us in Ibiza
was an Irishman, O'Brien.
He was a **MISFIT,**
like no one else
I've ever known.
He kept his distance
from the educated circles,
clerics, magistrate officials...

Mostly, he occupied
himself with LIZARDS.
From the way he caught
lizards to his cooking,
sleeping, & THINKING,
it seemed he did
NOTHING the way
others do it.

O'BRIEN busied himself with fishing, casting
the fish trap plaited from reeds
a hundred metres and deeper down,

Where the rock lobsters walk
on the craggy sea bed...

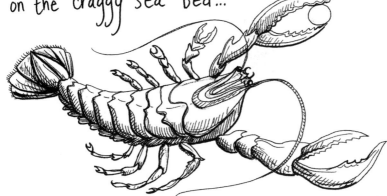

As I have already said, he was a MISFIT.
The path would always lead him
BACK TO THE SEA.

He had his own theory of dreams—

—DREAM IMMUNIZATION—

a fail-safe means to ward off nightmares,
those tormenting visions which recur
in sleep. One need only conjure up
the terrifying vision in the evening,
before one goes to sleep, in order to be
protected from it by night.

And finally, THOUGHT. (and relaxation).
O'Brien promised to teach me this discipline
and to induct me into all of its secrets,
from carrick bends and reef knots to spider
knots and Herculean knots.

SHEEP-SHANK

"for Knotting is a yoga-like art;
maybe the most wonderful of all means
of RELAXATION. One learns it through
practice and more practice — not only
in the water, but at home, in the calm,
in the winter, when one is GRIEVING
and TROUBLED. You would not believe
how often I have found solutions
to questions that burdened me through this."

DOUBLE FLEMISH LOOP DOUBLE-BOW KNOT

Sometimes, on awakening, we remember a DREAM.

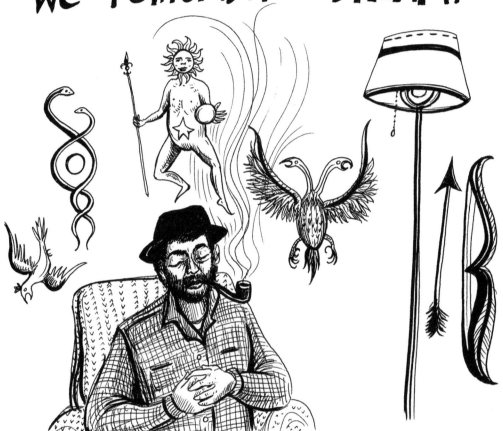

In this way, rare shafts of insight illuminate the ruins of our energy, heaps of rubble time has passed by.

Words in a DREAM are random products of the same meaning, which resides in the wordless continuity of a flow.

The BALL. For the sake of what prelude do we cheat ourselves of our DREAMS? With a wave of the hand we push them aside into the pillows, leave them behind, while some of them flutter silently about our raised head...

Oh, the brightness!

All of us carry around *invisible dreams*

AFTERWORD
BY SCOTT BUKATMAN

Walter Benjamin wrote several pieces about children's literature, and these writings constitute, for me, something of a manifesto on the intertwined phenomena of intellectual and aesthetic engagement. There are few evocations of reading more joyous than those in which Benjamin recalls what it was like to read as a child. He marveled at "The Wild Swans" by Hans Christian Andersen, in which

> there is a picture-book that cost "half a kingdom." In it everything was alive. "The birds sang, and people came out of the book and spoke." But when the princess turned the page, "they leaped back in again so that there should be no disorder." Pretty and unfocused, like so much that Andersen wrote, this little invention misses the crucial point by a hair's breadth. The objects do not come to meet the picturing child from the pages of the book; instead, the gazing child enters into those pages, becoming suffused, like a cloud, with the riotous colors of the world of pictures. Sitting before his painted book … he overcomes the illusory barrier of the book's surface and passes through colored textures and brightly painted partitions to enter a stage on which fairy tales spring to life…. Draped with colors of every hue that he has picked up from reading and observing, the child stands in the center of a masquerade and joins in, while reading—for the words have all come to the masked ball, are joining in the fun and are whirling around together, like tinkling snowflakes.[1]

1. Walter Benjamin, "A Glimpse into the World of Children's Book," in *Selected Writings*, ed. Marcus Bullock and Michael W. Jennings, vol. 1 (Cambridge, MA: Harvard University Press, 1996), 435. Originally published in 1926.

The materiality of the book, its surface, is only an "illusory barrier" to the life that lurks within the page, a life that is activated by the imagination of the child-reader. That reader is deeply invested in the engagement—in *One-Way Street*, Benjamin writes that the child's "breath is part of the air of the events narrated, and all the participants breathe it." The snowflake metaphor returns: "the hero's adventures can still be read in the swirling letters like figures and messages in drifting snowflakes."[2] It's a very unhurried encounter, quiet and intimate. It's also deeply reciprocal.

Frances Cannon's project in this book performs just this reciprocity—to excerpt and illustrate portions of Benjamin's writing as she has is to honor it on its own terms. What Cannon has produced is something more than merely an illustrated version of Benjamin; neither is it a standard linear comic, with its grids and specific reading protocols. Instead, it's an impressionistic collage; a translation, in that, in a sense—in Benjamin's sense—the writing is brought to life. Benjamin wrote that translations issue from the original, "not so much from its life as from its afterlife," but he in no way means to imply that translations are not alive. Rather, as is the case here, they can revivify, as much through difference as fidelity.

This book constitutes a playful encounter, a joyful masquerade. Terry Castle has argued the work of eighteenth-century masquerade balls "was that of de-institutionalization"—at the masquerade, hierarchies are upended, the world goes topsy-turvy.[3] How many children's stories turn on mistaken (or even swapped) identities? These masquerades are liberatory; for a time, all things are possible. In the masquerade ball that is the children's book, all join in the fun, the game, the play. Lynda Barry, exploring the nature of creativity, writes, "I believe a kid who is playing is not alone. There is something brought alive

2. Walter Benjamin, *One-Way Street*, in *Selected Writings*, 1:463. Originally published in 1928.

3. Terry Castle, *Masquerade and Civilization: The Carnivalesque in Eighteenth-Century English Culture and Fiction* (Stanford, CA: Stanford University Press, 1986), 78.

during play, and this something, when played with, seems to play back."[4] Benjamin makes it clear without ever stating it in these terms: reading involves a similar kind of play.

Benjamin's fascination moved beyond children's books to encompass printed matter of all kinds, the ephemera of modern life, and the fleeting nature of phenomena. Fragments are telling, and much of his own writing comes to us as fragments, most especially in his uncompleted, uncompletable project on urban arcades. Cannon's book is also a celebration of fragments, in its entirely personal selection of texts, its pictures of objects divorced from their functions (many adapted from variegated sources), and its lively admixture of illustrations, diagrams, and words.

Benjamin's texts are brought to life not only by Cannon's vivacious illustration, but also through the translation from anonymously typeset text to her calligraphy. The very words, as much as the images, become a part of the catalog, the constellation, of objects and ideas that comprise Cannon's selection. True to Benjamin's spirited act of reading, "the words have all come to the masked ball, are joining in the fun and are whirling around together, like tinkling snowflakes."

The vivacious experience of reading that Benjamin and Cannon extol and enact is anathema to vast swathes of that highly institutionalized, hierarchical, and gate-keeping world known as academia. There, readings are singularly purposeful, and scholars are Responsible—years of specialized training serve to legitimate their work. Unmasking, rather than the play of masquerade, is the order of business. The academy is a site of *gravitas*. But what of *levitas*—something lighter, something more playful?

When G. K. Chesterton visited America in the early 1920s, his response to the visual cacophony of Broadway displayed characteristic cheek: "What a glorious garden of wonders this would be," he remarked, "to any one who was lucky enough to be unable to read." He posited a naive peasant somehow

4. Lynda Barry, *What It Is* (Montreal: Drawn and Quarterly, 2008), 51.

wandering into this electric circus, who might think that "he had arrived on an evening of exceptional festivity, worthy to be blazoned with all this burning heraldry." Once literacy set in, however, the sight would become considerably more banal. As he reports on what he calls, yes, the "masquerade" of New York, Chesterton rejects the elite consensus on its spectacle: "I disagree with the aesthetic condemnation of the modern city with its sky-scrapers and sky-signs. I mean that which laments the loss of beauty and its sacrifice to utility." Such jaded responses are too easy, and demand the denial of sensual pleasures. And then he writes some lines that resonate resoundingly with my own sense of mission: "If a child saw these coloured lights, he would dance with as much delight as at any other coloured toys; and it is the duty of every poet, and even of every critic, to dance in respectful imitation of the child."[5] For "critic," substitute "academic," and there you are.

Chesterton and Benjamin, however much they might otherwise differ, meet in their regard for an earlier kind of engagement, one that involves dance and play and delight, an enchantment that should never become completely lost to us. The reciprocal activation of minds and texts, the eagerness to be enchanted, the vitality of strange encounters—these should be urgent components of adult intellectual labor. For "labor," substitute "play." Effective scholarship need not suck the joy from the world. Academics would do well to "dance in respectful imitation of the child." And to be fair, many do (or I wouldn't be here).

Cannon's approach is not academic, but neither is it anti-academic. It's intellectual and playful in equal measure, enchanted and enchanting. I believe that I hear an echo of Benjamin when Roland Barthes writes of his own production, "the work proceeds by conceptual infatuations, successive enthusiasms, perishable manias,"[6] and in those same terms I recognize Frances Cannon's

5. G. K. Chesterton, *What I Saw in America* (London: Hodder and Stoughton, 1922), 33–40.

6. Roland Barthes, *Roland Barthes*, trans. Richard Howard (New York: Hill and Wang, 1977), 110.

accomplishment here. Cannon is in dialogue with Benjamin—we see his enthusiasms, infatuations, and manias taken up by her; we watch her engage with Benjamin's writing in ways that echo and even amplify aspects of Benjamin's engagement with the world. This is a deeply inviting book, one that invites the reader into its world, and one that animates the world of that reader. Join the fun, the masquerade, the dance.

REFERENCES

Barry, Lynda. *What It Is*. Montreal: Drawn and Quarterly, 2008.

Barthes, Roland. *A Lover's Discourse: Fragments*. New York: Hill and Wang, 1978.

Barthes, Roland. *Roland Barthes*. Trans. Richard Howard. New York: Hill and Wang, 1977.

Baudelaire, Charles. *Paris Spleen*. Trans. Keith Waldrop. Middletown, CT: Wesleyan University Press, 2010.

Benjamin, Walter. *The Arcades Project*. Ed. Rolf Tiedemann. Trans. Howard Eiland and Kevin McLaughlin. Cambridge, MA: Harvard University Press, 1999.

Benjamin, Walter. *Berlin Childhood circa 1900*. Trans. and with commentary by Carl Skoggard. New York: Publication Studio, 2015. Earlier translated as *Berlin Childhood around 1900*, trans. Howard Eiland (Cambridge, MA: Harvard University Press, 2006).

Benjamin, Walter. *Illuminations: Essays and Reflections*. Ed. Hannah Arendt with updated preface by Leon Wieseltier. Trans. Harry Zohn. 1969; repr., New York: Schocken Books, 2007.

Benjamin, Walter. *Reflections: Essays, Aphorisms, Autobiographical Writings*. Ed. Peter Demetz. Trans. Edmund Jephcott. New York: Harcourt Brace Jovanovich, 1978.

Benjamin, Walter. *Selected Writings*. Ed. Marcus Bullock and Michael W. Jennings. 4 vols. Cambridge, MA: Harvard University Press, 1996–2006.

Benjamin, Walter. *The Storyteller: Tales out of Loneliness*. Ed. and trans. Sam Dolbear, Esther Leslie, and Sebastian Truskolaski. Illustrations by Paul Klee. London: Verso, 2016.

Benjamin, Walter. *Walter Benjamin's Archive: Images, Texts, Signs*. Ed. Ursula Marx, Gudrun Schwarz, Michael Schwarz, and Erdmut Wizisla. Trans. Esther Leslie. London: Verso, 2015.

Benjamin, Walter. *The Work of Art in the Age of Its Technological Reproducibility, and Other Writings on Media*. Ed. Michael W. Jennings, Brigid Doherty, and Thomas Y. Levin. Trans. Howard Eiland et al. Cambridge, MA: Harvard University Press, 2008.

Butler, Judith. "Melancholy, Ambivalence, Rage." In *The Psychic Life of Power: Theories in Subjection*. Stanford, CA: Stanford University Press, 1997.

Castle, Terry. *Masquerade and Civilization: The Carnivalesque in Eighteenth-Century English Culture and Fiction*. Stanford, CA: Stanford University Press, 1986.

Chesterton, G. K. *What I Saw in America*. London: Hodder and Stoughton, 1922.

Cixous, Hélène. "Without End, No, State of Drawingness, No, Rather: The Executioner's Taking Off." In *Stigmata: Escaping Texts*, trans. Eric Prenowitz. London: Routledge, 2005.

Eiland, Howard, and Michael W. Jennings. *Walter Benjamin: A Critical Life*. Cambridge, MA: Harvard University Press, 2014.

Freud, Sigmund. *On Murder, Mourning, and Melancholia*. Trans. Shaun Whiteside. London: Penguin, 2005.

Gardner, Jared. "Archives, Collectors, and the New Media Work of Comics." *Modern Fiction Studies* 52, no. 4 (Winter 2006): 787–806.

Sebald, W. G. *The Emergence of Memory: Conversations with W. G. Sebald*. Ed Lynne Sharon Schwartz. New York: Seven Stories Press, 2007.

Sebald, W. G. *The Rings of Saturn*. Trans. Michael Hulse. New York: New Directions, 1999.

Sontag, Susan. *Under the Sign of Saturn*. New York: Farrar, Straus and Giroux, 1980.